ERIC ANGEVINE

HINKLE FIELDHOUSE

INDIANA'S BASKETBALL CATHEDRAL

THE
History
PRESS

Published by The History Press
Charleston, SC 29403
www.historypress.net

Copyright © 2015 by Eric Angevine

All rights reserved

First published 2015

Manufactured in the United States

ISBN 978.1.62619.613.1

Library of Congress Control Number: 2014959939

CONTENTS

1. A Unique and Special Place to Play 5
2. An Auspicious Beginning 10
3. Heyday 25
4. World War II and Buckshot O'Brien 45
5. The Golden Years of High School Basketball 55
6. What's in a Name? 76
7. All Good Things Must End 88
8. Scoring Records, the Cold War and *Hoosiers* 101
9. Resurgence 112
10. Mid-Major Powerhouse 122
11. Springboard to the Final Four 134
12. The Campaign for Hinkle 146

Bibliography 151
Index 153
About the Author 160

1
A UNIQUE AND SPECIAL PLACE TO PLAY

The new year was less than a week old when a howling winter storm swept through the Midwest. The cold front was dubbed the "polar vortex" by the media. It froze the surface of Lake Michigan so quickly that the peaks of individual waves could still be seen, as if waiting for Mother Nature to release the "pause" button so time could flow normally again.

Several feet of snow fell on central Indiana over the course of five days, slowing daily life to a crawl. Citizens of the state dug out, chipped ice and sipped from steaming mugs as they went about their daily lives. In Indianapolis, state employees crab-walked past a snowman that had been assembled on an urban sidewalk. Life, in other words, went on.

Indianans are accustomed to working hard in all types of weather, and they had good reason to power through the workweek, even in such harrowing circumstances—the weekend promised ample opportunities to play hard as well. The city's beloved Colts were in the NFL playoffs, headed for a date with the New England Patriots. The Indiana Pacers—in first place in the NBA standings—were hosting the surging Washington Wizards. The IUPUI (Indiana University–Purdue University Indianapolis) Jaguars had a home basketball game and a swim meet taking place in the same building at the same time, and the Butler Bulldogs would welcome the Georgetown Hoyas to legendary Hinkle Fieldhouse for the first time.

The neighborhoods around Butler's campus were still largely impassable as game time approached on Saturday, January 10, 2014, but the crucial intersection where West Forty-ninth curved into Sunset Avenue had been

scrupulously cleared for game day traffic. The street was aptly named; the winter sun was, indeed, just falling toward the western horizon, illuminating the length of Hinkle Fieldhouse as it set. Happy knots of shivering fans dressed in blue and white trudging toward the field house must have been awed by the sight that greeted them.

Brick façades arched on either end. Long, horizontal windows ran the length of the roof. Uppercase white letters spelled out HINKLE FIELDHOUSE—as iconic to basketball fans as the Hollywood sign is to film buffs. Solid and functional but also elegant and nestled in an expanse of untrammeled snow, Hinkle Fieldhouse exuded a warm glow from within, inviting students, alumni and out-of-town visitors in from the cold.

And they had come, weather and a crowded sports calendar notwithstanding. The ticket office bustled as chattering fans entered the vestibule, unwinding scarves and tugging gloves from half-frozen fingers. For most, the field house was as familiar as home, and they moved comfortably around the narrow corridors to find their seats, where old friends waited. Visitors, some in the hallowed hallways for the first time, moved more slowly. They looked up, ran their fingers along the bricks and snapped photographs. Some gazed at the cases filled with trophies, plaques and historical documents. Others waited in line outside the tiny bookstore, eager to fill a bag with mementos of their visit. Many just wandered, reverentially absorbing the experience.

Hinkle Fieldhouse has that effect on people.

The grand old building has been standing in Indianapolis since 1928, and it has hosted thousands of basketball games in that time. Legends of the game played and coached at Hinkle, and even they only scratch the surface of the history contained within the building. Jesse Owens sprinted to a record at Hinkle. American soldiers and sailors trained in the building before heading overseas to fight in World War II. U.S. presidents from Herbert Hoover to Bill Clinton spoke to crowds gathered under Hinkle's steel arches. The field house has hosted evangelists, ice shows, tennis matches, bike races and even roller derbies. Athletes from around the globe have brought Olympic-level competition to the field house throughout the decades. The climax of *Hoosiers*, one of the greatest sports movies ever made, was filmed under its roof.

Even in that context, the basketball game against Georgetown on that January evening was something special. It was to be the Hoyas' first visit to Hinkle, brought about by that season's reformation of the Big East conference. Georgetown, Providence, St. John's, Marquette, Villanova, DePaul and Seton Hall—private schools without large football programs—

had split off to form a basketball-centric league away from the gridiron arms race. Butler, along with Creighton and Xavier, had joined the league as well and was playing out its first season against new competition.

Georgetown came into Butler's gym with an air of basketball royalty. The Hoyas had been to the National Collegiate Athletic Association (NCAA) tournament twenty-nine times, played in the title game four times and taken home the crown in 1984 under the leadership of hall of fame coach John Thompson. They walked into Hinkle Fieldhouse with high expectations, off to a 10-3 start to the season under the legend's son, John Thompson III. JTIII, as the coach was known, had reason to feel comfortable in these new environs. Pacers star George Hibbert, a recent Georgetown alum, had come to wish his alma mater well and take in the game from the stands. In addition, Thompson's best player, sophomore guard D'Vauntes Smith-Rivera, had played three years of high school ball right down the road at Indianapolis North Central.

Things were rather different for Butler's first-year head coach, Brandon Miller. The Bulldogs' recent run of national success had widened the program's recruiting base beyond the Midwest. As the rafters echoed with cheers from the capacity crowd, he sent out an opening lineup of Floridian Khyle Marshall, Louisville's Kameron Woods and Ohio native Alex Barlow,

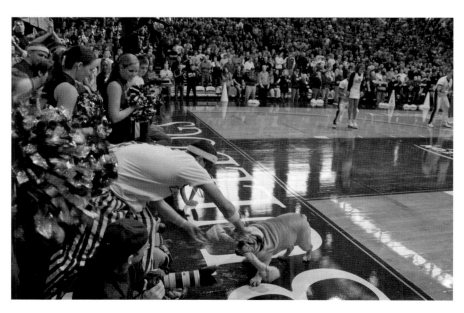

Butler's bulldog mascot Blue gets a warm welcome at the beginning of every game in Hinkle. *Author's photo.*

alongside Indiana-bred Kellen Dunham and Erik Fromm. On the Butler bench were players from as nearby as New Castle, Indiana, and as far away as Sydney, Australia. But their origins were no matter—they were all schooled in the unselfish, efficient, methodical style of basketball known as the Butler Way.

As the game got underway, it became clear that many of the fans in attendance were pulling for Smith-Rivera, even in his visitor's jersey. Cheers rang out for the native son during player introductions, and friends and family shouted encouragement as the sophomore set the tone for Georgetown's offense early on. Smith-Rivera's defensive rebounding, sure passing and shooting touch staked the visitors to an early 11–4 lead.

Georgetown was simply too big inside, outscoring its host 24–8 inside on its way to a 34–29 halftime lead. Unruffled, Butler fans watched their stalwart Bulldogs chip away at the Georgetown lead in the second half, taking a 1-point lead with just over three minutes left in regulation play. Reserve Andrew Chrabascz—a freshman forward from Rhode Island—made his presence felt, leading the offensive rebounding effort, hitting all of his free throws and missing just one shot from the floor as the Bulldogs forged a 60-all tie to end the first forty minutes of basketball.

Overtime in Hinkle Fieldhouse was electric. Butler scored the extra period's first 3 points before Smith-Rivera stole the ball from Chrabascz to ignite a strong closing run for the Hoyas. Kellen Dunham's final 3-pointer fell short at the buzzer, and the Hoyas eked out a hard-earned 70–67 win.

After the game, Smith-Rivera was humble. He had starred in his return to his hometown, notching eighteen points, seven rebounds and five assists, and he admitted that he wanted to excel in the iconic field house. "It meant everything," he said. "I really wanted to come here and get a win, because I knew it would be packed."

Thompson was also mindful of the big picture, alluding to the aura known as "Hinkle mystique" in his postgame comments.

"This is a unique and special place to play," he acknowledged.

The nation is full of iconic sports venues, so what is it about Hinkle Fieldhouse that evokes such reverence? At the time of Thompson's comments, the building had stood for over eighty-five years, earning local fame as the home of Butler basketball under legendary head coach Tony Hinkle and as the home of the Indiana State High School basketball title game.

Over time, the field house became more than that, an American treasure preserved and honored by inclusion on the National Register of Historic Places. It is Indiana's Basketball Cathedral, inhabited by the ghosts of

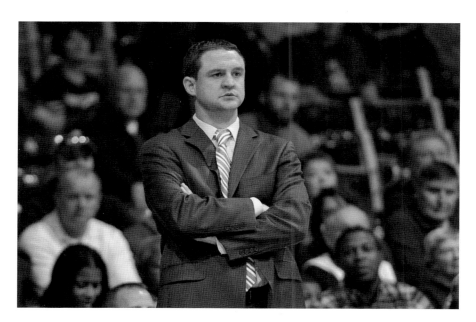

Former Butler player Brandon Miller was made head coach after Brad Stevens left in 2013. *Butler University.*

young athletic heroes and wise mentors and the accumulated experiences of thousands of men and women who have walked the building's hallways. Hinkle Fieldhouse is more than bricks and mortar; it is also made up of the sights, smells and sounds of nearly a century of life.

It is full of stories that are waiting to be told.

2

AN AUSPICIOUS BEGINNING

The structure originally known as Butler Fieldhouse was built for basketball. It was not, strictly speaking, built for Butler basketball.

Butler University, at its founding, did not resemble the college as it is today. In fact, it wasn't even known by that name until its twenty-fifth year in existence.

In the late 1840s, an Indianapolis lawyer named Ovid Butler proposed the creation of a private, Christian campus in his hometown, and the Indiana state legislature approved the notion on January 15, 1850. Butler provided a parcel of land at the corner of Thirteenth and College Streets on the northern edge of the city proper, and North Western Christian University was chartered.

The university was founded on Protestant Christian principles by members of the Disciples of Christ denomination, but it was never formally owned or operated by the church. In the years before the U.S. Civil War, the church's precepts were considered somewhat liberal and radical. The school's charter called for "a non-sectarian institution free from the taint of slavery, offering instruction in every branch of liberal and professional education." Ovid Butler's university was also one of the first in the United States to offer coeducational learning and the first to endow a professorial chair for a female professor. Catharine Merrill was the first pioneering woman to hold the Demia Butler professorship, to which she was appointed in 1869.

North Western Christian University was a small school with big ideas, and it soon grew beyond the bounds of its original home. In 1875, the school

moved to a twenty-five-acre plot in the Indianapolis suburb of Irvington, reinventing itself in the process as Butler University "in recognition of Ovid Butler's inspirational vision, determined leadership, and financial support."

Dr. James Naismith, a practitioner of the healthy spirit-mind-body philosophy known as "muscular Christianity," was tasked with achieving an elusive goal in 1891. Several instructors at the Springfield, Massachusetts YMCA had tried their hands at inventing an engaging organized activity that could be played indoors during the brutal northern winters. Ideas had come and gone, but nothing had yet incorporated the blend of skill, entertainment and sheer physicality required to enthrall the bored workingmen who frequented the Y.

Naismith blended elements of different games together and tried his creations out on groups of willing volunteers each day. His first few attempts were failures, but then he hit upon the idea of a horizontal goal raised above the players' heads. He chose a soccer ball as his scoring object and asked the Springfield YMCA's superintendent of buildings for a box to serve as the goal. In his memoir, *Basketball: Its Origin and Development*, Dr. Naismith notes that it was Superintendent Stebbins who made the first crucial outside contribution to the game, telling Naismith, "I haven't any boxes, but I'll tell you what I do have. I have two old peach baskets down in the store room, if they will do you any good."

The game was a hit from day one, and it soon spread like wildfire throughout the nation. History is hazy on exactly when the game first took root in the state of Indiana, but records at Butler indicate that twenty-one students were given varsity awards in the sport in 1893. It seems reasonable to assume that the state was in the vanguard of the sport's initial wave of popularity.

The school had a tiny gymnasium in those early years, with minimal space for players and no accommodation for spectators. The nascent basketball program struggled with these limitations and even had to cancel the season in 1913–14 because opponents refused to play in their on-campus facility. Afterward, the school often was forced to play a heavy slate of road games and hosted home games in other city buildings, not always convenient to the school's Irvington campus.

In contrast, high school basketball had taken the state by storm. Over seven hundred schools across Indiana played varsity basketball, and competition was intense and extremely partisan. The first statewide tournament was convened in 1911, and fans couldn't get enough. They stood in long lines to cheer on their Bearcats, Hot Dogs, Artesians and various other collections

of hometown heroes. Trophies were sources of eternal pride and bragging rights even more so.

Following World War I, returning soldiers swelled the enrollment ledgers at Butler. By the early 1920s, the school was again on the lookout for a new location, one with plenty of room to grow. On the northwestern fringes of Indianapolis, a large tract of land that had once housed the Fairview Amusement Park was available, so the school engaged architects to design a new campus to suit that land, with buildings to serve the burgeoning student body.

Even as it experienced unprecedented growth, Butler was not large by the standards of a state-sponsored school. It enrolled just over one thousand students, most of whom were expected to sit their classes in a Gothic-style building known as Arthur Jordan Memorial Hall. This was the first building planned for the new Fairview campus, and its mission was decidedly academic in nature.

So how did a small private school end up building what was then an immense marvel of modern architecture? A fifteen-thousand-seat sports palace that could hold every student, professor and administrator the school had and still feel yawningly empty? It was the intersection of timing, opportunity and need that set the auspicious history of Butler Fieldhouse in motion—that, and a particularly rabid form of basketball fandom that came to be known as Hoosier Hysteria.

THE ORIGINS OF HOOSIER HYSTERIA

High school basketball was hugely popular in Indiana at the turn of the twentieth century, but it was a scattered, hyper-regional affair. Teams chose their own schedules, which often matched them with squads from the local YMCA or a nearby college. The rules of the game were very fluid in those early days, and ethical abuses were common. Not only did high school teams play against adult men in official competition, but there were also no rules explicitly stating that members of the high school team actually had to be enrolled at the institution. Fans, players and coaches craved consistency in the game. Naturally, they also wanted to know which team, given a reasonable opportunity to prove itself in competition, could claim to be the best.

The Athenians of Crawfordsville, for example, styled themselves as state champs in 1901 after playing just one game against a high school rival. The Crawfordsville boys beat Indianapolis Shortridge High that year and

The Crawfordsville Athenians declared themselves Indiana's high school basketball champions in 1901, despite having played (and defeated) just one other team of their peers. *Crawfordsville District Public Library.*

believed that the transitive property of sports victories gave them the title because Shortridge had beaten another city team from Manual Training School. It wasn't exactly science. Some governing body, with guidelines, schedules and rules, was needed.

In the waning days of 1903, a Board of Control was elected, and the Indiana High School Athletic Association (IHSAA) was officially created. Fifteen schools signed on as charter members. By April 1904, that number surged to thirty-three. One year after its charter document was introduced, the IHSAA boasted seventy-one members. The business of forging a statewide standard of basketball had begun.

In 1910, Crawfordsville finished the season 13-1 and again claimed for itself the unofficial state title. Rival Lebanon objected, noting that its 20-2 record boasted seven more wins, which more than offset the additional loss. To make matters worse, the two teams had split a home-and-home series during the season, further muddying the waters. The teams could

The Crawfordsville YMCA is considered to be the "Cradle of Basketball" in Indiana. This YMCA membership card is from 1911, the year the Athenians won the first official Indiana High School Athletic Association basketball title. *Crawfordsville District Public Library.*

not come to terms on a third, winner-take-all game, leaving the matter forever unsettled.

The next year, the Indiana Booster Club proposed a twelve-team tournament to be played at Assembly Hall on Indiana University's Bloomington campus. Lebanon and Crawfordsville, which had again split their season series, were among the dozen teams invited to the "First Annual State Interscholastic Basket Ball Tournament," which commenced on March 10, 1911. After the morning sessions on March 11, only three teams remained undefeated: Crawfordsville, Lebanon and Bluffton. A drawing determined that Lebanon would receive a bye to the final while the other two teams battled for the right to play them.

Not to be denied a rematch with its bitter rival, Crawfordsville destroyed Bluffton by a score of 42–16, earning the team the chance to play again that same evening against a relatively fresh Lebanon squad. It was to be Crawfordsville's third game that day. S. Chandler Lighty of the Montgomery County Historical Society described the first half of the game in a paper profiling the Crawfordsville team:

Crawfordsville evidently shook off some of their weariness after the opening tip, and rushed out to a 7–1 lead in the first five minutes. After this opening run, Lebanon responded, and "started some of their brilliant team work. Beautiful passes…[left] the Crawfordsville lads…utterly bewildered at times in following the ball. Despite their fancy passing the Lebanon men couldn't score, blowing about four out of five shots right under the basket." The half ended with Crawfordsville still in control, 13–7. [Crawfordsville coach Dave] Glascock recalled that at half-time, "The boys said, 'Coach, if we win this game we're all going downtown and really celebrate.' I told them if they won the game I didn't care what they did."

Crawfordsville kept sniping away at the goal in a way that Lebanon could not, winning the game by a final score of 24–17. When tourney organizers presented the championship trophy to Glascock, his players had disappeared, perhaps off to paint the town red, as promised. Any visions of outrageous behavior the coach might have entertained were soon laid to rest. "When I went back to the fraternity house where we were staying," the victorious coach recounted, "I found them all sound asleep, worn out completely."

That first title game had all the elements that turned Indiana's high school basketball postseason into the spectacle now known as Hoosier Hysteria: passion, skill, endurance and no small measure of regional animosity. The only thing the state basketball tournament didn't have—yet—was a permanent home.

TONY HINKLE ARRIVES

In 1921, a young man graduated college with the future wide open ahead of him. Paul Daniel Hinkle had been a three-sport star at the University of Chicago. The Logansport, Indiana native had been a pitcher, shortstop and cleanup hitter for his alma mater's baseball team and a prolific pass catcher for the football team, which was coached by the legendary Amos Alonzo Stagg. Perhaps his greatest achievements had occurred on the hardwood, where his skills as a scorer, defender and ball handler helped Chicago earn the 1920 Big Ten championship.

Hinkle had heard from Major League Baseball manager John McGraw, who wanted him to report for training with the New York Giants. The sport

Hinkle's brick exterior façade is enhanced with Indiana limestone. *Author's photo.*

had recently outlawed Hinkle's best pitch, the spitball, so a future as a big-league hurler seemed like a long shot. Basketball, specifically coaching, offered more promise as a career choice.

Chicago's head coach, Pat Page, had resigned that spring, leaving Stagg as the interim coach of both football and basketball. Stagg asked Paul Hinkle to assist him with the team while the younger man was completing his undergraduate requirements. The taciturn "old man"—who had worked with James Naismith at the Springfield YMCA when the game was invented—hadn't tendered an official contract offer, but he seemed to value Hinkle's work and wanted him to stay on.

Pat Page had other plans. He had coached Hinkle through a brilliant career as a basketball guard and knew the man very well. In fact, Page had given the young athlete his nickname ("Tony"), which would stick with him for life. "According to Hinkle, Coach Page coined it during a road trip when Hinkle came out of a restaurant carrying an extra serving of spaghetti and meatballs," wrote Howard Caldwell in his biography of Hinkle. Apparently the name "Tony" sounded a bit more appropriately Italian for a spaghetti-loving kid than "Paul" in Page's opinion. Page asked Tony Hinkle to join him as an assistant at Butler University, where the athletics program was undergoing a renaissance.

Stagg's largely unspoken and rather formal regard for Paul Daniel Hinkle meant a great deal, but Pat Page's avuncular directness and the opportunity to return to his home state won the day. The young coaching savant chose the route of assistant basketball coach at Butler University in Indianapolis. It was a decision that would come to define the man and the school alike.

RAISING THE FIELDHOUSE

When Pat Page assumed his duties as athletic director and multisport coach at Butler, the basketball team was playing in an abandoned army facility. Page added bleachers to the ramshackle space, raising its effective capacity to six hundred spectators. When Page asked Tony Hinkle to be his assistant coach in 1921, he made the younger man an assistant athletic director as well. No doubt both men began to focus on the need for better facilities immediately.

Butler University began the process of moving to the expansive Fairview Park location shortly after Page and Hinkle were hired. Hinkle was head

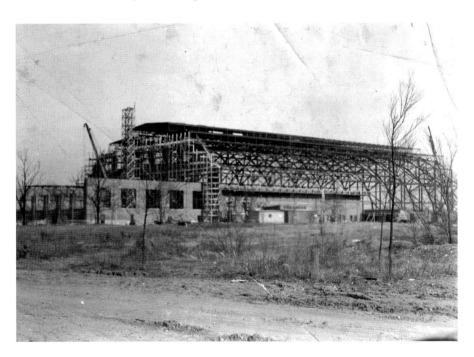

This rare image shows Butler Fieldhouse under construction in 1926. *Butler University.*

coach of the school's baseball team in 1924, when the first organized sport was played at the new location. A diamond was drawn up in a grassy expanse, surrounded with markers that indicated where future academic buildings would be constructed. On May 17, 1924, Hinkle brought his alma mater, the University of Chicago, to this literal field of dreams, and his Blue Sox (as the school's baseball team is known) christened the new campus with an 8–6 victory, played in front of around two thousand fans.

One academic building was scheduled to be built first on the Fairview campus. Jordan Hall would anchor the space near the baseball diamond and house several classes until other buildings could be completed. Roughly a half mile northeast, an even more ambitious structure, Butler Fieldhouse, was planned.

The university accepted a bid from Fermor Spencer Cannon, a local architect who had designed some prominent Northside homes. Cannon's design was excellent, combining practical concerns, such as sight lines and adequate lighting, with a strong aesthetic that made the building beautiful and soulful.

The arched steel trusses that formed the bones of the field house supported the roof over a large interior space with no poles blocking the view for pedestrians. The roof was, in architectural parlance, a three-stage monitor roof, with long horizontal windows running from end to end. The western end of the building

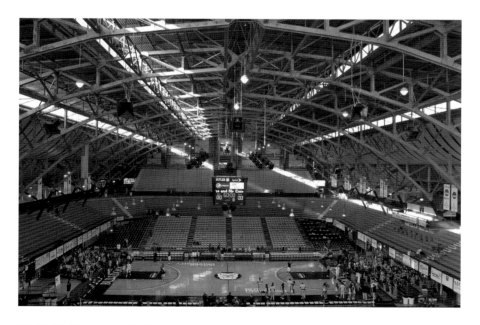

Hinkle Fieldhouse's arched steel trusses meant there were no poles to block fans' sight lines. *Author's photo.*

had a brick wing that housed a swimming pool and gymnasium.

The eastern end had no wing attached. There, Cannon added a touch that has resonated with visitors ever since: seven vertical gable windows. The windows mimicked the shape of the arch, resembling a professor's grade distribution bell curve. The exterior of the building was solid brick, with limestone accents.

Butler Fieldhouse was Fermor Spencer Cannon's crowning achievement. It embodied the spirit of Indiana: strong, vast and subtly handsome and well appointed without being too flashy. It was a masterpiece.

The Butler Bulldogs opened the building in 1928 with a 21–13 overtime victory over in-state rival

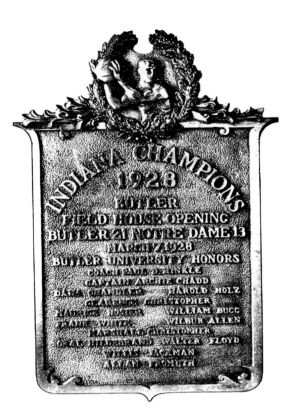

A plaque commemorates the first college basketball game played in Butler Fieldhouse. The Bulldogs defeated in-state rival Notre Dame 21–13. *From* The Drift.

Notre Dame. Newspaper accounts from the time casually mentioned that part of the lower-level seating collapsed, but the incident didn't stop the game. Going forward, the building would, in fact, be rock solid.

JOHNNY WOODEN COMES TO TOWN

Anyone who follows college basketball knows that John Wooden built his legendary coaching career at UCLA, where he earned ten national titles over a twelve-year period, including seven in a row during one incredible stretch.

Fermor Spencer Cannon's design for Butler Fieldhouse included ramps for reaching the second level, an innovative concept in 1926. *Indiana High School Athletic Association.*

Few will remember that he coached at Indiana State Teacher's College (now Indiana State University) for two years prior to his time in Los Angeles, and even fewer think much on his All-American playing days at Purdue. Looking further back to his boyhood, Wooden represented an Indiana archetype: a basketball-crazed kid from a tiny town.

"My family had lived on a farm until my father took a job as a massage therapist at one of the artesian spas in Martinsville," a ninety-three-year-old Wooden reminisced in Jeff Washburn's *Tales from the Indiana High School Basketball Locker Room*. "I started playing basketball, and in 1926, my life changed forever."

Plenty of small towns were mad for basketball, but the people of Martinsville had put up money to prove their commitment. In early 1924, the town had built what was then the world's largest high school gymnasium. The Martinsville gym held 5,382 souls—more than the town itself could boast—and seats never went empty. A reporter for the town's *Daily Reporter* newspaper recalled the scene on game day: "The big gym was packed to capacity, and the cheering throng, the music by the bands and the brilliant display of school colors presented a scene never to be forgotten by those who were present."

The gym opened when young Johnny Wooden was a freshman, a country boy who had never seen so many people in one place before. Wooden loved football and baseball, but the school didn't field teams in either sport. Wooden's experience illuminates something about the early growth of basketball in Indiana: before school districts began to consolidate, rural towns like Martinsville often didn't have enough athletes to excel at anything other than basketball. What might have appeared to be a weakness to outsiders soon became the state's biggest strength. Every athlete in every tiny town was a potential superstar in this relatively young sport.

Wooden—again by the luck of geography—came under the tutelage of Glenn Curtis. The Martinsville head coach already had two high school championships to his name when he began molding Wooden's skills and character. Johnny Wooden's elder brother, Cat, had been on the 1924 title-winning team, but the "Old Fox," as Curtis was known, hadn't seen fit to put the elder boy on the floor very often. It was a sore point for Cat's kid brother, as John Wooden biographer Seth Davis recounted in *Wooden: A Coach's Life*:

> [Curtis broke] *up a fight between Wooden and one of his teammates. In Wooden's eyes, Curtis had unfairly backed up the other fellow. "You're not going to do to me what you did to my brother!" Johnny shouted. He flung off his jersey, his shorts, his shoes, and his socks, and he stormed off the floor in half-naked protest. He decided then and there to quit the team.*

Fortunately for Wooden and the sport of basketball in general, the Old Fox was a gracious man who knew how and when to forgive. He coaxed

Wooden back onto the team and redirected Johnny's youthful passion into an exemplary high school career.

By 1926, Johnny Wooden was a starter for the Artesians. Martinsville won its sectional and advanced to Indianapolis, where the state finals were being played in the Indianapolis Exposition Center, colloquially known as the "cow barn." Martinsville lost the final to Marion High School, led by six-foot-eight Charles "Stretch" Murphy. In those days, there was a center jump after each made basket, which gave the aptly nicknamed Giants a decided advantage.

Wooden, on the other hand, was a quick, agile guard with a keen shooting eye and little regard for his own safety. "I've never seen another player give everything, regardless of what might happen to him, the way he did," recounted Birch Bayh, one of the officials at the 1927 state title game. "He would score by flying in from the side and use his bank shot. Many times he would slide on the floor and wind up under the bench…He held nothing back." That approach served Wooden well, as Bayh could attest. Johnny scored 10 points in Martinsville's 26–23 win over Muncie Central in his return to the cow barn in 1927, earning the Artesians a third state title.

In Wooden's senior season, it was almost a foregone conclusion that Martinsville would be back for a shot at a championship repeat. This time, however, the Artesians would play their ultimate games of the season at Butler's new, million-dollar field house. The gleaming cathedral of basketball was packed to the rafters, and scalpers were asking as much as twenty-five dollars apiece for tickets, an astronomical sum in 1928. Those who couldn't make their way inside sat rapt by their radios, taking in every dribble.

The radio announcers had their work cut out for them. There was no shot clock, and the Artesians were masters of slow-down basketball. The Muncie Bearcats tried to speed up the game, but the sure hands of Johnny Wooden kept them at bay. Once he got ahold of the ball, nobody could take it away, and he was free to dribble around and watch the clock run until he saw a shot—for himself or a teammate—that was a virtual sure thing.

The score was 9–8 at the half. In the second stanza, Muncie got within 2 points, and Curtis slowed the game down so much that neither team scored for a full five minutes. With sixty seconds left in the game, Martinsville led 12–11 and was running out the clock.

It was then that Muncie's center, Charlie Secrist, had an idea. He called a timeout, knowing full well that his team had none left. It was a technical foul. That meant Martinsville would shoot a free throw, and Muncie would have the opportunity to get the ball back at the center jump. Johnny Wooden lobbied to decline the free throw and retain possession but was overruled by

This banner celebrating Muncie's 1928 high school title, the first won in Butler Fieldhouse, hangs in the Indiana Basketball Hall of Fame. *Author's photo.*

the Old Fox. Wooden—an excellent free throw shooter—aimed a careful underhand shot at the basket…and hit the rim. His team still held a one-point lead, but now Secrist would get his center jump and a chance to pull out a win for Muncie.

Secrist's plan was to tip the ball to himself (allowed by rule at the time) and lob it toward the backboard, where one of his teammates would have a chance to grab the rebound for an easy score. He got the first part right, securing the ball and then tossing it underhand as his smaller teammates dashed to the end of the floor. Then something odd and stunning happened: the ball dropped straight through the net, barely disturbing the twine. Secrist's pass had become Secrist's amazing shot, and the Bearcats of Muncie held a 13–12 lead. Wooden's team miraculously secured the center jump for a last-second attempt, but Martinsville big man George Eubank was unable to finish on Wooden's long pass.

The Martinsville Artesians, who had come so close to repeating as state champs, sat on the floor and cried. Johnny Wooden's special high school career was over, but his impact on basketball worldwide had barely begun.

On the other end of the floor, Charlie Secrist celebrated with his teammates. While Secrist would not become a household name like John Wooden, he had played the hero on the big stage and begun a tradition that would characterize basketball in Hinkle Fieldhouse for years to come: dramatic, incredible, game-winning shots.

3

HEYDAY

Butler University's 1928–29 basketball season would turn out to be something special. It was bound to be a banner year for young head coach Tony Hinkle regardless—he married his sweetheart, Jane Murdock, at eleven o'clock on June 28, 1928. In typical Hinkle fashion, the wedding was meticulously planned and elegantly executed, without a lot of fanfare. It was a small, private event; only close friends and family were there to witness the nervous groom wearing out the soles of his shoes with frequent circuits around the Marott Hotel before he braced himself and took the plunge.

The newlywed Hinkles were dedicated to each other, and Tony was dedicated to coaching. Somehow, the couple worked out a compromise: Jane was welcome at any home football, baseball or basketball game at Butler, but he preferred that she didn't accompany him on the road. Somehow the time-sharing arrangement worked. The Hinkles stayed happily married, and the Bulldog cagers embarked on their most successful season to date.

TITLE TOWN

Butler's basketball team had won the Amateur Athletic Union tournament in 1924, defeating relatively unknown opponents Schooley-Woodstock, Hillyards and Kansas State Teacher's College to reach the title game. In front of ten thousand fans in Kansas City, Missouri, the Bulldogs, led by 12 points from

Haldane Griggs, defeated the Kansas City Athletic Club, which was heavily salted with former Missouri Tigers. The 30–26 postseason win gave Butler the right to call itself national champ. The sport was still a long way from the current model of deciding titles, but the 11-7 Bulldogs had proved their mettle on the court, mounting a winning streak when it counted.

Tony Hinkle was an assistant coach in 1924, still learning his craft from Pat Page. By 1928, he had been head coach for two years and was ready to apply the lessons he'd learned at the feet of the master.

Hinkle built his team around solid athletes from the Hoosier State. His ten-man roster in 1928 boasted eight players from central Indiana and two more from such exotic locales as Terre Haute and Fort Wayne. Four of those Hinkle disciples would go on to become coaches themselves, and one, Oral Hildebrand, was starting pitcher in a World Series game with the champion New York Yankees in 1940. This tightknit group was steeped in the disciplined Hinkle style, and it would carry the team members far.

Hinkle insisted on crack execution on offense and defense, but his personal style of coaching was anything but tyrannical. In Howard Caldwell's

The natural light coming in the field house's monitor level windows is part of Hinkle's charm. *Indiana High School Athletic Association.*

biography, *Tony Hinkle: Coach for All Seasons*, William Bugg, a member of the 1928 team, recalled his coach's tough but fair approach:

> *"Tony was good on fundamentals from the beginning," Bugg said in 1989. "Sometimes he would go out on the floor and spend twenty-five minutes participating in one drill." And when it came to handling a moody player, Bugg made the observation: "Hildebrand was an excellent ballplayer, but he was like a little boy. If something went bad out on the floor not to his liking, he just took off and went up into the bleachers and sat down* [during practice]. *Somebody said something about it to Tony, and Tony said 'Just leave him alone, he'll change his mind. He'll be back down. He's just a kid. He'll get over it.' That's exactly what happened. Tony just didn't make a scene of it."*

Such forbearance would be anathema to most coaches then and now, but somehow, Tony Hinkle made it work.

Butler opened the season against a dangerous foe. The Pittsburgh Panthers had gone 21-0 the year prior and were later named national champions by the Helms Foundation. Pitt head coach H.C. "Doc" Carlson had earned national respect by taking his teams on road trips to play top midwestern teams, and he was ready to try his hand against the Bulldogs. Hinkle's squad pulled out a 35–33 thriller, announcing its own presence on the national stage in dramatic fashion.

Before the NCAA came along, there were no divisions based on college size, and coaches commonly scheduled teams from within their geographic region. Butler took on a powerhouse Purdue program after slipping by Pitt. John Wooden was a freshman at the school then, at a time when first-year athletes were not allowed to play varsity, but future hall of fame coach Ward "Piggy" Lambert had six-foot-six junior Charles "Stretch" Murphy claiming the center jump in 1928. His team would go on to win the Big Ten that season. Despite that, Hinkle's boys eked out another nail-biter, taking a 28–27 victory over the Boilermakers in Butler Fieldhouse.

The Bulldogs easily handled Danville Normal and then laid an absolute pasting on North Carolina, winning 47–24. Butler took down a strong Missouri squad next but then suffered its first setback of the season, losing at Hinkle's alma mater, Chicago, in a dreary 24–21 slog. They bounced back in style, tearing through Franklin, DePauw, Indiana Central and Evansville (twice). Notre Dame stunned the Bulldogs—by that pesky 24–21 margin—beating them in front of a partisan Butler

Notre Dame's field house was built in 1898. The modest, four-thousand-seat building got loud. Kentucky legend Adolph Rupp famously said he could not win at the "Snakepit." *Notre Dame University.*

Fieldhouse crowd and setting up a crucial rematch to be played in South Bend at the end of the season.

When Hinkle's team arrived at the Notre Dame Fieldhouse, it was nursing a 16-2 record. The Irish played in a building far older than the massive edifice the Bulldogs called home. The Notre Dame Fieldhouse was initially built in 1898, championed by then Notre Dame president Andrew Morrissey. The new gym promptly burned down, but Morrissey, not to be deterred, built a new "fireproof" building, incorporating the cornerstone from the ill-fated first field house.

Notre Dame's field house looked like a castle from the outside. Inside, it had the familiar arched ceiling beams and vertical windows that Fermor Spencer Cannon had used at Butler, but it was much, much smaller. A single level of seating allowed four thousand or so fans to crowd around the raised, portable basketball floor in the center of the arena. The setup apparently brought out the animal in Notre Dame's fans. A 1968 *Sports Illustrated* story recalled students doing their "best hyena imitations," and frustrated

BASKETBALL SCHEDULE, SEASON OF 1929

December 13—Pittsburgh, here.

December 21—Purdue, here.

January 1—North Carolina, here.

January 3—University of Missouri, here.

January 5—Chicago University at Chicago.

January 11—Franklin, here.

January 18—Evansville, here.

January 25—DePauw, here.

February 8—Wabash, at Crawfordsville.

February 11—Franklin at Franklin.

February 15—Notre Dame, here.

February 22—DePauw at Greencastle.

March 6—Wabash, here.

March 9—Notre Dame at South Bend.

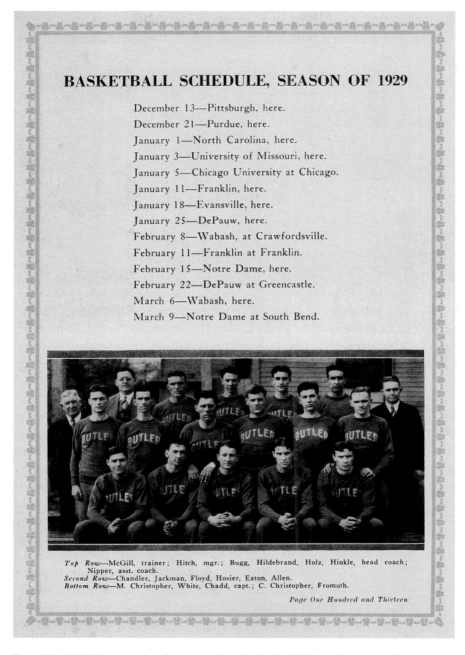

Top Row—McGill, trainer; Hitch, mgr.; Bugg, Hildebrand, Holz, Hinkle, head coach; Nipper, asst. coach.
Second Row—Chandler, Jackman, Floyd, Hosier, Eaton, Allen.
Bottom Row—M. Christopher, White, Chadd, capt.; C. Christopher, Fromuth.

Page One Hundred and Thirteen

Tony Hinkle's 1929 team played a tough schedule, finished 17-2 and was named national champs by the Veterans Athletic Association of Philadelphia. *From* The Drift.

opponents referred to the building as the "Snakepit." Legendary Kentucky coach Adolph Rupp claimed he could not win there. It was a deafening, intimidating place to play basketball.

Hinkle's Bulldogs came in with revenge in mind, and they got it. Oral Hildebrand had, as Tony Hinkle predicted, shaken off his sulk and led the visitors with 11 points. A convincing 35–16 triumph in Notre Dame's turn-of-the-century dungeon made a convincing statement. Butler University's basketball team was, by its own reasoning, champions of the basketball-crazed state of Indiana. Its overall record of 17-2 was about to earn the team further accolades.

In his book *The Butler Way*, *Indianapolis Star* journalist David Woods recounted the day that Hinkle and his cagers learned that they were champions of much more than just their home state:

> *The Veterans Athletic Association of Philadelphia announced on December 16th that Butler was the national champion. The Bulldogs' strength of schedule and rout of Notre Dame were both persuasive. Hinkle and team captain Frank White traveled to Philadelphia in February 1930 for a banquet honoring all of the 1929 champions. Riding on the train with them was Notre Dame football coach Knute Rockne.*

Hinkle was always reluctant to play favorites, but when asked in 1991 which team was his best ever, the legendary coach replied, "That's a tough one to ask a fella…it was 62 years ago. We had a lot of fine teams. It's tough to say, but it must have been. The voters said so!" Hinkle was slyly referring to his 1929 national title winners.

THE CRASH

The news was not all good during this time. October 24, 1929, was "Black Thursday," the day the U.S. stock market began to crash, losing an estimated $30 billion in value in a matter of days. The Great Depression had begun, and thoughts of economic hardship must have dogged the minds of Hinkle, White and Rockne as they rode that train eastward in triumph. In fact, questions of money and how it was spent would soon lay Butler's defending national champions low.

In early 1930, the North Central Association of Colleges and Universities (NCACU) announced that it would strip Butler University of its academic accreditation. The governing body called Butler's library "inadequate" and declared the faculty-to-student ratio to be too high for its taste. Primarily, however, the North Central Association believed that Butler was emphasizing athletics to the detriment of the school's academic mission. The expenditure of $750,000 for athletic facilities—primarily spent on the construction of the field house—was apparently beyond the pale for a small private school with a relatively meager endowment.

Butler's athletic funds did, in fact, come from a source many in post-crash America would have found distasteful. A separate corporation, described by the school's yearbook, *The Drift*, as "an incorporated body of forty-one Indianapolis businessmen and financiers, alumni and friends of the University...cooperating with the University Board of Directors and other executives, has control of Butler's athletics." This organization raised money for the Bulldogs' various athletic programs by selling stock. Throughout a struggling nation, financial speculation was a deeply unpopular avocation, best not mentioned in polite company.

Tony Hinkle's only connection to the suspension was that his teams played in the embattled field house. The university was called on to defend its logic in building the massive structure, as detailed by Howard Caldwell in *Coach for All Seasons*:

> Butler's response to the criticism was that the fieldhouse was not intended to be used exclusively by Butler. The administration pointed out that the building was to be made available to the community and that the Indiana High School Athletic Association had agreed to use it for the next fifteen years for the annual state high school basketball tournament if its seating space was increased. That is why the school raised the capacity to fifteen thousand.

The suspension hung over members of the basketball team as they tried to defend their 1929 title.

The 1929–30 season started well enough. The Bulldogs ripped off five straight wins to open the campaign, including a huge 36–29 win over Purdue. The Boilermakers went on to win the Big Ten that year, but they were without the services of Johnny Wooden when they came to the field house. The Purdue guard had suffered severe lacerations to his leg in an automobile accident and spent game day in a hospital bed, never getting to trot out onto the field house floor in Purdue black and gold.

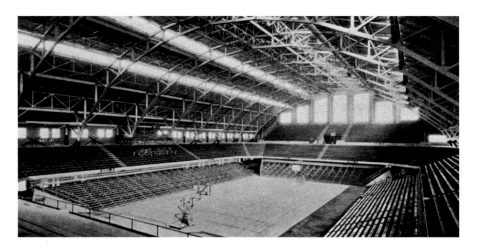

The field house floor originally ran east–west, but it was reoriented in 1933 after athletes complained of being blinded by the sunlight coming in the east windows. *Butler University.*

The Bulldogs also earned wins over Vanderbilt, Nebraska and Illinois before another suspension laid them low. Oral Hildebrand, who was team captain that year, had accepted money while playing baseball that summer. He was ruled ineligible at midseason. The team finished 12-7, suffering home and away defeats to old nemesis Notre Dame. It wasn't a terrible season, but it was far less successful than Hinkle and the team's fans had anticipated.

Butler University survived the suspension and was reinstated after only one year of official censure. The school increased its library holdings by 50 percent and increased the endowment fund to $5 million. The main casualty of the NCACU's action was Butler athletic director Potsy Clark, who resigned in August 1930. The *Indianapolis Times* said only that the resignation was believed to be "linked to the suspension of the school." The program's new director, Harry Bell, would take over and would coach the football team as well.

The Butler cagers rebounded with a 17-2 season in 1930–31, beating Cincinnati, Brigham Young, Alabama and Arkansas. They defeated Louisville twice. A glacial 20–15 come-from-behind win over Notre Dame in the field house was the capper on a bounce-back season that had the Bulldogs back in the national spotlight. The *Indianapolis Star* reported rumors that the University of Michigan wanted Hinkle to take over the basketball program in Ann Arbor.

Tony Hinkle stayed at Butler, and his loyalty paid off. When Harry Bell managed just five football wins in two seasons, he resigned and the athletic director's job went to Hinkle. The new boss named himself baseball coach,

Butler fans tailgate outside Hinkle Fieldhouse for football and basketball. *Butler University.*

but another man was hired to walk the football sidelines. That arrangement didn't last; Fred Mackey won just four contests in two years, and when he was fired, Hinkle took that job, too. He was to amass one of the most impressive all-around coaching résumés in collegiate sports, helming three sports for the Bulldogs with only a brief interruption until his retirement in 1970.

A PRESIDENTIAL VISIT

If there was any lingering doubt that Butler Fieldhouse was more than an overgrown basketball gym on a small campus, it was laid to rest in 1932. President Herbert Hoover, battling for reelection against an upstart Democratic governor by the name of Franklin Roosevelt, chose the field house as the venue for a major stump speech. With additional floor seating added, over twenty-two thousand listeners were able to hear the president speak in person.

Hoover's speech was broadcast on radio by the Columbia Broadcasting Service and National Broadcasting Corporation and recorded for posterity.

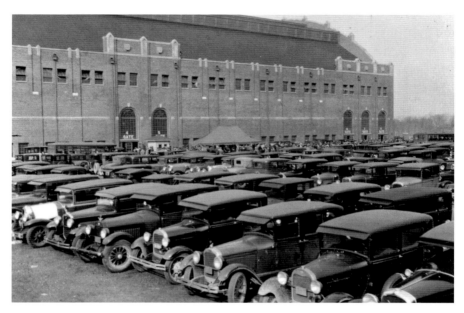

An unknown photographer captured this image of Butler Fieldhouse surrounded by Model T Ford automobiles, circa 1930. *Butler Archives.*

The president took the podium at 7:30 p.m. on October 28, just days before the 1932 election would take place.

Hoover's speech began the only way it could with the country in the grips of financial catastrophe. The president stated clearly that "the most important issue before the American people right now is to overcome this crisis, that we may secure a restoration of normal jobs to our unemployed, recovery of our agricultural prices and of our business, and that we may extend generous help in the meantime" to those in distress.

Stung by Roosevelt's assertion that he had done nothing to reverse the country's fortunes in two years, Hoover laid out a defense of his policies and actions. The speech had some barbed words for the president's rival and detailed some concrete steps taken by the Hoover administration to combat unemployment. The meat of the address was a lengthy exploration of the benefits expected to accrue to Indiana and other agricultural states if the president were to be granted another term to pursue his policy of protective tariffs.

By today's standards, it was a windy speech. When Hoover said, roughly one-third of the way into his speech, "Now to continue our mathematical explorations a little further..." one must wonder what was going through the

minds of the assembled thousands who were listening to his voice bouncing around the field house's beams. The president roused himself to eloquence a bit later, expressing his confidence that he could "drive [Roosevelt] from every solitary position he has taken in this campaign" and evoking the image of a chameleon on Scotch plaid to characterize his opponent's political inconsistency.

Hoover scored points there, noting that Roosevelt had, in 1928, served as chairman of the organizing committee of the Federal International Banking

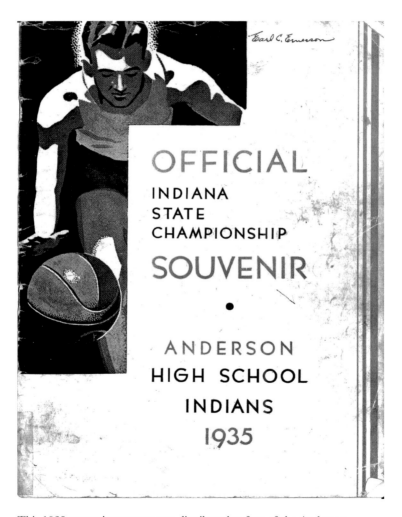

This 1935 souvenir program was distributed to fans of the Anderson Indians, who triumphed over Jefferson to take the state title that year. *Indiana High School Athletic Association.*

Company, "a corporation organized for the selling of foreign securities and bonds to the American people." Speculation and foreign investment were considered to be root causes of the financial crash of 1929, and Roosevelt had naturally spoken against such activity throughout his 1932 election campaign.

In retrospect, Hoover may have referenced his opponent a little too often, or too well. When defending himself against Roosevelt's attacks, he repeated the tidy phrases the New Yorker was fond of: "President Hoover has failed children" may not have been the best words to repeat, even in self-defense. Another of Roosevelt's phrases, "The bunk of the Home Loan bank," also had some cachet. Hoover even mockingly echoed Roosevelt's most catchy and enduring term: the New Deal.

Hoover closed his speech with an appeal to the American people to hold fast:

> *My countrymen, I repeat to you, the fundamental issue of this campaign, the decision that will fix the national direction for a hundred years to come, is whether we shall go on in fidelity to American traditions or whether we shall turn to innovations, the spirit of which is disclosed to us by many sinister revelations and veiled promises.*

With millions unemployed and food riots breaking out in major American cities, the nation was not prepared to wait and hope for the best. In early November, 22.8 million Americans voted for the man who was offering a new deal, sweeping Franklin Delano Roosevelt into office.

JESSE OWENS AND THE BUTLER RELAYS

Butler Fieldhouse was built with basketball in mind, but the massive edifice presented opportunities for the university's other sports as well. Butler track coach Herman Phillips, a former collegiate champion and Olympic gold medalist, founded an indoor track meet in 1933, reconfiguring the vast interior space of the field house in an ingenious way. The Butler Relays grew quickly, as described by R. Dale Ogden in the *Encyclopedia of Indianapolis*:

> *The event annually showcased 350–400 athletes representing 20–30 colleges and universities. From an attendance of 3,500, the games grew to attract over 10,000 spectators to Butler Fieldhouse each March. The*

Kate Smith, famous for her rendition of "God Bless America," visited the field house locker room to wish Butler's Ray Sears good luck before the 1934 Butler Relays. *Author's collection.*

college's fraternities and sororities vied in yearly ticket sales, parade float, house decoration, and Relay Queen competitions. The University Division "Governor's Cup" went to each year's victor, with Indiana University claiming the inaugural trophy and the University of Notre Dame taking

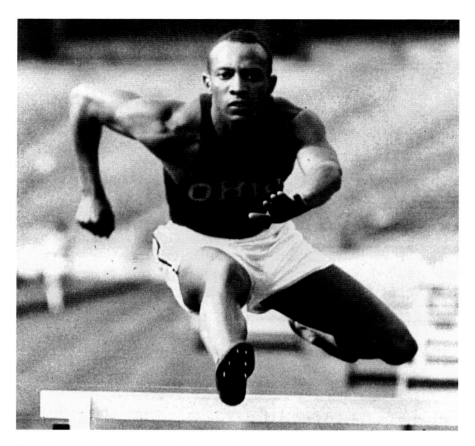

Jesse Owens tied a world record inside the field house at the 1935 Butler Relays. *Ohio State Athletics.*

the final prize. The University of Michigan captured the eight intervening awards. Butler claimed the College Division "Mayor's Trophy" between 1938 and 1941. In addition to the participation of legendary American Olympians Jesse Owens, Glenn Cunningham, Ralph Metcalfe, and IU's Don Lash, the Butler Relays saw ten world records set or tied during the meet's decade-long run.

Of those records, the most dramatic and noteworthy was one of the ties. Jesse Owens of Ohio State University took off like a shot in the 1935 running of the sixty-yard dash. He came in first, notching a time of 6.1 seconds and tying a world record. Owens and the other competitors had to crash into a temporary barrier made of hay bales to come to a stop.

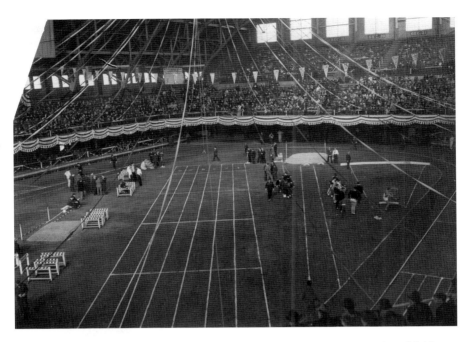

An ingenious layout was employed in order to fit all of the Butler Relays track and field events inside the field house. *Butler University.*

Owens went on to become an American hero one year later, winning four gold medals at the Olympic games in Berlin, Germany. Adolf Hitler could only stand and watch as a black American destroyed his notions of Aryan superiority.

THE PIANO RECITAL

To open National Music Week in May 1936, Sigma Alpha Iota, the national professional music sorority, sponsored a grand piano recital. A total of 125 pianos were brought to the field house, and 825 pianists played a variety of songs and accompanied the combined choirs of Butler University and the Arthur Jordan Conservatory of Music. A total of 8,250 fingers played in what was, at the time, the largest piano recital ever held.

Susan Sutton curates historical photographs for the Indiana Historical Society and wrote a book titled *Indianapolis: The Bass Photo Company Collection.*

She recalled the day she unexpectedly discovered her own family's link to the historic concert:

> *Around 2006, my father and I were visiting with his sister. My aunt's name was Corrine Stanfield Staples, and I think she was ninety-one years old at the time. While we were visiting, we began talking about their childhood in the 1930s.*
>
> *My grandfather was born in Indiana. But he moved west as a young man, so my father and aunt were born in South Dakota, about thirteen months apart. They both started school at the same time, and had similar memories of the Depression. They had watched their farm blow away in the Dust Bowl—cattle died and the crops failed. My father talked a little about what it was like to see everything around them turn to dust in the severe droughts. He mentioned women despairing because they couldn't keep the dust out of their houses—it even seeped into chests of drawers. The landscape became horribly bleak.*
>
> *The conversation rambled a bit, and we finally got to talking about when the family moved from South Dakota to Indiana in 1933. A family member*

Fans from towns large and small filled the field house for big high school games for decades. *Indiana High School Athletic Association.*

had lured my grandfather back to Indiana, saying he could probably get a small farm here. My aunt and my father were about to graduate from high school. Moving to Indiana made my father perfectly happy—he absolutely loved anything growing. My aunt, though, was more of a social being, and she missed her friends. She was especially unhappy about moving.

Recounting the story over seventy years later, she did recall one silver lining: her parents offered her piano lessons, which she hadn't been able to have in South Dakota, as compensation for the move. When she got to that part of the story, she said that the really exciting thing about it was that she was able to play in a huge recital in Indianapolis. This caught my interest because I had seen this wonderful photograph of the recital in Butler Fieldhouse, so I asked her if she remembered where it was held. Yes, she said, it was indeed at Butler in the field house. She couldn't remember where she was in the crowd or the music she played, but I got chills as soon as she mentioned it. I had never heard her talk about it before, and I had always found the photograph strangely fascinating.

She smiled as she told the story. The piano lessons and the very special recital brightened an awful season of loss for her.

BICYCLE RACES

In February 1937, with basketball season in full swing, the field house hosted a hugely popular one-off event: a six-day marathon bicycle race. Such events are little known today, but they were big business in the first few decades of the twentieth century. Top athletes from around the world competed on a circuit that stopped in most of America's large cities. Madison Square Garden was frequently filled to capacity with enraptured spectators. Between 1890 and 1939, more than seventy-five six-day bike events were held.

In some cities, the event literally went for six days, with teams of riders hurtling around a wooden oval in shifts, tagging off like modern-day professional wrestlers. The rider who was off shift bolted down massive quantities of food and drink to replace the calories and sweat he had lost and then slept in a makeshift wooden shelter for a couple of hours of shut-eye while his partner buzzed around and around to the delight of strangers.

Why would seemingly sane men put themselves through such an agonizing torture test, week in and week out? Money. According to Peter Nye, historian at the U.S. Bicycling Hall of Fame, marathon bicycle racing was one of the

top-paying jobs an athlete could hold in those days. "When Ty Cobb was playing for the Detroit Tigers and winning American League batting titles, his annual salary was $5,000," Nye said. "He held out for the 1910 season and got $10,000. There were about a dozen bike racers making $20,000–$25,000 at that time." One racer who came over from Australia made enough in a single season to pay cash for a new home in the United States.

The relays were the most well-known part of the event, but the organizers also sponsored daily matinee sprints to gin up excitement and get paying customers in the door. "There would be ten two-mile sprints, and the first five across [the finish line] would get points that would count toward the total," Nye said. "And there would be money on the line for each of the sprints."

There was plenty to appeal to a sporting connoisseur during a visit to the bicycle races. Inside the purpose-built wooden oval was an infield section, where a full band played dance hits of the day. It was common for organizers to invite celebrities to act as honorary race starters. "The atmosphere was very exciting, with the band playing, the announcer on a megaphone shouting into the crowd and the racers just flying," Nye said. "There would be fifteen teams of two riders each, and the guy who's been on the track for a while is getting relieved by his friend who's been resting. The points tally would go up as the six days progressed, and on the final day, you'd get double or triple points awarded to the top five finishers."

It was a cutthroat business, and teammates might not finish a race together. "There were spectacular crashes, and sometimes a crash would knock a guy out of the race," Nye said. "The structure was that if somebody crashed so that they were injured, his uninjured partner could wait around, and then when someone else crashed, the remaining partners would constitute a new team with a one-lap penalty." If the new team won cash, they were under no obligation to share the bounty with their injured cohorts.

Butler's race was a bit of an oddity. The school's faculty and students made a vocal protest against the full marathon format, claiming that the event would undercut academic activities on campus. Race organizers compromised, limiting the races to a twelve-hour chunk in each of the six days. Wabash College was scheduled to take on the Bulldogs in the field house as well, and the game went on as scheduled. The Bulldogs, mired in an abysmal campaign, earned one of their six season victories during a break in the race hoopla, beating their in-state rival 30–24.

The banked oval built inside Butler's grand edifice was remembered as one of the fastest tracks in the country that season. Local carpenters built the track from scratch, garnering crucial jobs in tough economic times. An

estimated thirty thousand spectators watched the races over the course of the on-again, off-again seventy-two-hour entertainment bonanza.

The stars of the Indianapolis race were Gustav Kilian and Heinz Vopel, a legendary German team. "They were gods," Nye said. "They were strutting, cock-of-the-walk guys, a killer team. They were about the same size and swapped off really well in the two-man relays." The two men were so alike in size and skill that they were often mistaken for brothers.

Kilian and Vopel were the top team of their day, and they had a long string of dominating victories to their credit by the time they arrived in Indianapolis. They, like the other riders, were used to truly grueling twenty-four-hour-per-day races, and they made short work of the abbreviated field, taking home the overall crown in Indianapolis as well.

The looming specter of World War II eventually spelled the end of six-day races, as the multinational corps of riders dispersed to fight for their home countries. The departure of Kilian and Vopel was particularly dramatic, catalyzed by events of a race held in Chicago in November 1940, as recounted in Peter Nye's *Six-Day Bicycle Races*:

> *When it seemed obvious that another victory was in their grasp on the final night, they donned black armbands bearing the Nazi swastika and rode around the oval. Suddenly, the mood of 20,000 admiring spectators who filled the stadium changed to hostility. Booing and catcalls so riled the German duo that they packed up and sailed home to their fatherland to join the army.*

In spite of prevailing sentiments of the time, tolerance was a pillar of Butler University as a whole and the athletic department under Tony Hinkle. In 1937, a black athlete by the name of Tom Harding arrived at Butler, where he joined the football, baseball and track teams. Hinkle and Harding were tested when the football team traveled to Washington, D.C., in 1938, as related in *Coach for All Seasons*:

> *A few hours before the train was to leave, Hinkle met with Harding. He had received a telegram from George Washington University refusing to play Butler if Harding was allowed on the field. Tony told Harding he would cancel the game if Harding wanted him to. Harding said he thought the teams should play and that maybe someone would note the irony: a university in the nation's capital city was rejecting him because of the color of his skin.*

Harding sat on the bench in street clothes, and the Bulldogs lost that game, 26–0. Both men were pleased when GW played in the Butler Bowl the following season. Harding played, and scored twice, leading the Bulldogs to a 13–6 home win and a meaningful moral victory as well.

The '30s were very eventful years in the early life of the field house and proved to be an up-and-down decade for the Butler basketball team. The building's basketball floor had originally been laid out on an east–west axis, which often meant that free-throw shooters were blinded by the light streaming in the gable windows. The floor was re-oriented to the north–south layout we see today in 1933. The Bulldogs won consecutive Missouri Valley Conference titles in 1933 and 1934 and then had three losing seasons in a row from 1936 to 1938. By the end of the decade, Tony Hinkle had his team back in the black, but the growing clamor for war overseas would change everything.

WORLD WAR II AND BUCKSHOT O'BRIEN

Basketball was not likely the top subject on people's minds in 1940. War had broken out overseas, and while the United States would not immediately join in combat, many Americans believed it would be inevitable. In the meantime, the games went on at Hinkle Fieldhouse, at least for a couple of years.

THE FIELD HOUSE DOES ITS DUTY

When the United States was drawn into World War II by the Japanese bombing of Pearl Harbor, there was no question that Butler students and teachers would do their duty. Tony Hinkle joined the navy in March 1942 and was granted a leave of absence from his duties as coach and athletic director for the duration of his service. Hinkle was placed in charge of athletics at Great Lakes Naval Base (where current and future baseball All-Stars like Mickey Cochran and Larry Doby were temporarily assigned), and his loyal assistant, Frank Hedden, took his place as Butler's coach.

Hedden had been Tony Hinkle's head recruiter for years, haunting the city's hoops havens—he was particularly fond of Dearborn Gymnasium and Pennsy Gym—on the lookout for raw talent for Hinkle to shape. In those days, students frequently worked odd jobs to contribute toward their collegiate room and board, and Hedden was in charge of making sure

students' financial needs were tended to. Many out-of-town athletes came to rely on Hedden and bestowed the nickname "Pop" on the gregarious, portly and balding assistant coach.

"Pop" Hedden nearly didn't get a chance to coach Butler basketball at all. The university's board of directors considered canceling the 1942–43 season outright but eventually agreed to an abbreviated schedule, with home games to be played at Hammond Tech High School.

Games had to be played elsewhere because Uncle Sam needed the field house. The venerable wooden floor was taken up board by board and stored in an old horse barn at the state fairgrounds. The field house itself was partially converted into barracks space and used as a training school for naval personnel. The naval training school for signalmen took up residence in the grand old building, with a complement of two-hundred-plus trainees. In his book *Fulfilling the Charter*, Roger Boop describes the special role Butler played in the training of future sailors:

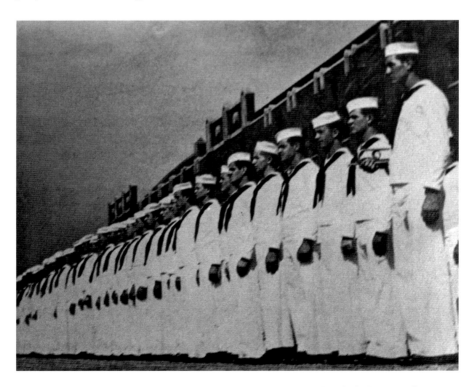

The U.S. Navy took up residence in Butler Fieldhouse in 1943. The building served as a training facility for the duration of World War II. *From* The Drift.

Basic chemistry, physics and mathematics courses were taught to resident Navy personnel at this time—some by the seniors at Butler! Butler was paid $70 per student per month for the matter of instruction and use of the Fieldhouse facilities.

Photographs from the Butler *Drift* yearbook and military yearbooks show sailors and, later, army airmen working, sleeping and exercising—then termed "physical hardening" in military parlance—with the field house as a backdrop.

With so many college-aged men signing up to serve the war effort, Pop Hedden was not able to muster a full-strength team of top athletes, but his charges made the best of a difficult situation. Pop Hedden's first team went 4-9. Then the basketball program skipped a year of competition before ending Pop's tenure with a decent 14-6 mark in the 1944–45 season.

When Tony Hinkle returned from his naval service in 1945, he resumed control of the athletic department and set about restoring the field house, and the team that played there, to full basketball readiness.

BUCKSHOT

You might think that Tony Hinkle would try to find some massive Hoosier plowboy to build his first postwar team around, but that was never really his style. The hero of Butler's end-of-decade team turned out to be a five-foot-nine local boy by the name of Ralph O'Brien. Indianapolis newspaperman David Woods explained how O'Brien's diminutive stature earned him a distinctive nickname in his book *The Butler Way*:

> *The front of the Depression-era grocery store was a gathering place for children on Indianapolis' West side. Winners of boxing matches—yes kids did that in the 1930s—would be rewarded with an apple or candy bar. Obviously, one kid would never win. Why, he was so small that he was the last one picked for choose-up-sides teams in the backyard. The grocer always recognized him.*
>
> *"He kept saying that I'd never be bigger than a buckshot," Ralph O'Brien recalled.*

And so Ralph became "Buckshot" O'Brien, in much the same haphazard way that Paul Hinkle became "Tony." Such is the way with nicknames.

Ralph "Buckshot" O'Brien starred for Butler in the post–World War II years. Later, he played professionally with the Indianapolis Olympians and became a television announcer for local broadcasts. *Author's collection.*

Buckshot's body may have been small, but his heart and will to win were huge. His first challenge as a freshman at Butler was to make the basketball team at all. With young men coming back from the war, Hinkle assistant Bob Deitz was given the task of winnowing two hundred interested athletes down to thirty or so realistic candidates. Six spots on the team were taken by players who had been cut from the Indiana basketball team by Branch McCracken, including future Indiana Basketball Hall of Famer Bill Shepherd, who would have his moments in Butler's field house as a player, high school coach and, eventually, a proud father—more about Shepherd's basketball dynasty later.

Against this tough competition, Buckshot still stood out. O'Brien had led all city and county scorers while playing for Washington High and been named to the Indiana All-Star team. He had considered going out of state to play basketball for Tulane but eventually succumbed to Tony Hinkle's low-key charm—which is not to say that the tough old coach went easy on the budding star athlete.

"I thought he hated me my freshman year," O'Brien told Woods. "He made me work out in the girls' gym playing defense while all the guys were on the big floor playing offense. He told me 'I know you can shoot. But I couldn't leave you out there if you couldn't guard anybody.'"

O'Brien debuted for Butler in a "reserve game," something like a junior varsity matchup of today. Tony Hinkle noticed that O'Brien played well in the opening exhibition, so he told him to dress out for that evening's varsity game against Wisconsin.

Buckshot logged just two minutes against the Badgers, but then his career took off. Five days later, he tied McCracken cast-off Charles Maas with 9 points, co-leading the scoring in a 2-point win over Pittsburgh. Later that season, in what was surely a joyous moment for Maas and the other men who had been run out of Bloomington, Indiana, O'Brien led all scorers as the Bulldogs sent the Hoosiers packing with a 52–41 loss. O'Brien and the Bulldogs put paid to Cincinnati, Ohio State and Purdue as well and finished the 1946–47 season with a respectable 16-7 record.

As a junior in 1948–49, O'Brien broke the Butler career scoring mark, leading a team that also included Marvin Wood, who would make his mark as a coach at Milan High in 1954. That team went 18-5, beat Indiana and Purdue in the Hoosier Classic and finished the season ranked number eighteen in the nation.

Buckshot's senior season was a bit of a letdown. The team finished 12-12, earning no team honors. O'Brien, however, was drawing a great deal of attention for his individual play. Howard Caldwell described how Tony Hinkle decided to let a little air out of O'Brien's tires one day:

> One afternoon in practice a man showed up in dark glasses, coat and hat pulled down low, carrying a notebook. Buckshot was told it was a man from Look magazine who wanted to get a look at Buckshot as he was preparing his All-American recommendations. The team went into a scrimmage and no one would pass the ball to O'Brien, who was getting more and more frustrated by the moment. Finally he stole the ball and took it to the basket at the other end. Shortly afterward, Hinkle introduced "candidate" O'Brien to Hinkle's brother-in-law.

As it turned out, Hinkle's prank was prescient. Buckshot O'Brien and teammate Jimmy Doyle were named to the prestigious *Look* All-American team. O'Brien played in a college All-Star game around the same time and impressed pro scouts with his defensive efforts against soon-to-be-legendary Bob Cousy.

Ralph "Buckshot" O'Brien—despite owning the Butler scoring record far and away with 1,248 points—figured his playing career was over because nobody would want such a tiny point guard. As it turned out, he wasn't nearly done with basketball in the city of Indianapolis.

CLYDE LOVELLETTE: NEARLY UNSTOPPABLE

Clyde Lovellette was famous from the moment he first entered the world. At the time, he was the biggest baby ever born in Pike County, Indiana. In the basketball-mad Hoosier state, basketball stardom might have seemed like a good bet, but Lovellette claims he never thought that way. "My father was an engineer on the railroad, and I thought that was a glamorous job," Lovellette told one writer. "When I was growing up I wanted to do that or be a state policeman, but I grew too tall for that. I wasn't too high on the academic block, but I knew there were things I could have fun doing."

Clyde may not have been high on the academic block, but he was large in stature, which made all the difference for him, even when it came to his schooling, as Blair Kerkhoff detailed in his book *Phog Allen: The Father of Basketball Coaching*:

> If he hadn't grown so tall, Lovellette might not have had incentive to stay in school. But grow he did, wide and strong as well as tall. He went from 6-4 as a freshman to 6-8 as a sophomore. He might not have seen his basketball potential then, but his mother, Myrtle, did.
>
> "She told me I was clumsy and that if I was going to play sports, I had to get unclumsy," Lovellette said. "She wanted me to jump rope. The only people I ever saw jumping rope were girls and I didn't want to do it. She said we could go in the back yard after supper where nobody would see us, and that's what we did. I got good at it. Mom also danced with me to help my coordination."

Clyde's workout secrets were well kept, but his mother's advice paid off. Lovellette was nearly unstoppable by the time his junior year at Terre Haute

A high school cheering section performs a song with choreographed movements. *Indiana High School Athletic Association.*

Garfield rolled around. In his penultimate year at the school, the six-foot-nine center was unclumsy enough to have his team flirting with perfection. Unbeaten by midseason, he and the Garfield Purple Eagles traveled to meet a regional rival.

The Shelbyville school system was segregated, so the high school's integrated team was composed of players who had not been playing together for long. In the fall of 1946, the Bears had two black players on the roster—Bill Garrett and Emerson Johnson—who were destined to become Indiana All-Stars by the end of the season. The game would prove to be controversial, as officials whistled five fouls on Garrett that were later described as questionable. The disgruntled home crowd reacted poorly, forcing local police to step in, restore order and give the Purple Eagles an escort out of town.

Garfield won that game and finished the high school season unblemished. The team proceeded to tear through the regional and state semi portions of the IHSAA tournament, booking its ticket to Butler Fieldhouse. As it turned out, Shelbyville had turned its season around and arrived on the other side of the bracket. In those days, the semifinal and final games were played all in

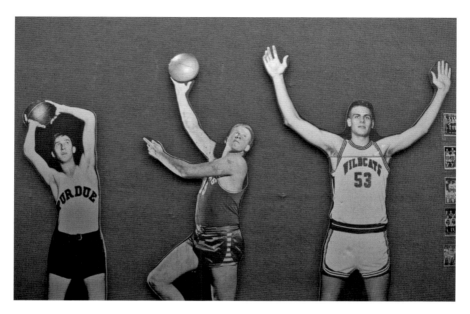

An Indiana Basketball Hall of Fame display featuring great "Big Men" from the state shows (from left to right) Stretch Murphy, Clyde Lovellette and Eric Montross. *Author's photo.*

one thrill-packed day, so the rivals were on track for a dramatic final face-off, as described in *The Golden Age of Indiana High School Basketball*:

> *Two afternoon wins set up the highly anticipated rematch between Shelbyville and Garfield, Garrett and Lovellette. As is often the case, someone else stole the show. Shelbyville's Emerson Johnson, who blamed the daylight streaming in through Butler Fieldhouse's upper windows for his dismal shooting performance that afternoon, hit eleven of thirteen shots in the final game for twenty-three points. Lovellette scored twenty-five and Garrett twenty-one, but Garfield never led, and never could find a way to stop Johnson. The Bears won, 68–58, for their first state title while ensuring that Indiana would go at least one more season without an undefeated state champion.*

Lovellette never gained a high school championship for Garfield, but his talent was undeniable. Like any good Indiana boy, he had no plans to leave the state to play in college and had already told Branch McCracken to expect him at Indiana in the fall of 1948. Kansas head coach Phog Allen was not about to give up the prize of the recruiting class so easily, however. The legendary coach

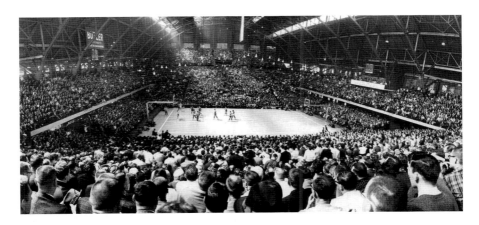

Fans in the nosebleed seats watch the 1963 Indiana High School Tournament in Butler Fieldhouse. *Indiana High School Athletic Association.*

showed up at the Lovellette household and described his vision of a national title plus an Olympic gold medal if Clyde became a Jayhawk. After a visit to Lawrence, Clyde agreed to sign on with Allen and Kansas.

Certainly, questions arose as to exactly how Allen had lured the big man away from the Hoosiers, but the man known as Phog met external doubts with jokes. "One big reason Clyde enrolled here was because the altitude helps his asthma," Allen joked to reporters. Lawrence is only 825 feet above sea level, and the KU campus, located on a hill known locally as Mount Oread, is 180 feet above downtown Lawrence.

In the end, however, Allen proved to be prophetic. The Jayhawks defeated St. John's for the 1952 national title and made Lovellette the centerpiece of the Olympic team that defeated Russia in a sluggish 36–25 gold medal game that same season. Big Clyde became a first-round draft pick of the Minneapolis Lakers, played eleven seasons as a professional and was named to the All-Star game four times. He was inducted into the Naismith Basketball Hall of Fame in 1988 and eventually returned to his home state to enjoy a well-deserved retirement.

THE HOOSIER CLASSIC

In the postwar years, Tony Hinkle dreamed up a holiday basketball tournament that would offer his team some stiff competition and hopefully

help fill the field house with spectators. The Hoosier Classic brought Purdue, Notre Dame and Indiana to Butler's campus for an intrastate battle. In order to preserve the in-season rivalry of Big Ten members Purdue and Indiana, Notre Dame and Butler, both independents, took turns playing the conference foes. The participants split the proceeds evenly.

The classic debuted on January 1, 1948. Butler defeated Indiana 64–55 on the first day of competition and then claimed a 4-point win over Purdue on the second day. The event had been well attended by alumni of the four participating schools, and it became a fixture of the holiday scene for the next several years.

THE GOLDEN YEARS OF
HIGH SCHOOL BASKETBALL

The 1950s were an extraordinary time for basketball in Indiana. The state basketball tournament was at the height of its popularity, and schoolboy athletes often took their first steps toward national stardom on the boards of Hinkle Fieldhouse.

A war hero turned president visited the building, as well, and professional basketball came to the Butler campus.

Indianapolis had hosted a professional basketball team called the Indianapolis Jets for one season. The Jets played in the Basketball Association of America (BAA) in 1948–49. A rival league, the National Basketball League (NBL), had agreed to admit a local team called the Olympians the next season, with home games to be played at Butler Fieldhouse.

During the offseason, the BAA and NBL agreed to merge to form the National Basketball Association (NBA). The Olympians survived the shakeup to become Indianapolis's sole representative in the new organization.

The makeup of the Olympians was somewhat amusing, given the long-standing basketball rivalry between the state of Indiana and the Commonwealth of Kentucky. A full six members of the team's inaugural lineup were former players from the University of Kentucky. Butler's Bob Evans was the lone local boy on the roster; he played in forty-seven games that season but didn't make much of a dent in the stat sheet. That year's team finished first in the NBA's Western Division but lost to the Anderson Packers in the finals.

The next season, even Evans was gone. The Wildcat-heavy Olympians came in fourth in the division that season and had a losing record, but they

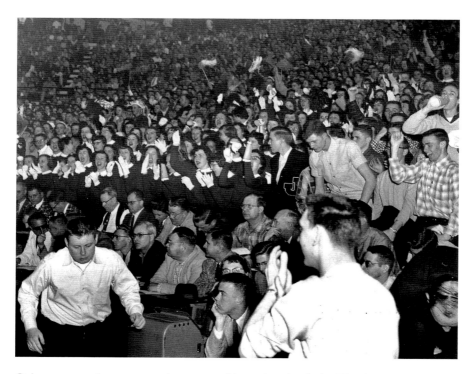

Only reporters who were on assignment could remain calm during Hoosier Hysteria.
Indiana High School Athletic Association.

still earned a playoff spot. The Minneapolis Lakers ended that dream quickly. That team did set a record that still stands as of this writing. They were 75–73 victors in the longest NBA game ever played, with six overtimes against the Rochester Royals in a game that was contested on January 6, 1951.

Following that season, scandal tainted the organization. Team leader Alex Groza, who had won consecutive NCAA titles at Kentucky, was implicated in a point-shaving scandal dating back to his final year in college. Ralph Beard, who had followed Groza to the Olympians, and Dale Barnstable, who had gone from Lexington to the Celtics, were implicated as well. NBA commissioner Maurice Podoloff banned all three from the NBA for life.

Native Hoosiers had more of an impact in the team's third season. Indiana University point guard Bill Tosheff joined the team as a rookie, and Butler great Buckshot O'Brien thrilled local fans by making the roster as well. Buckshot averaged nine points per game despite his diminutive stature. His team made the playoffs only to be swept by the Lakers.

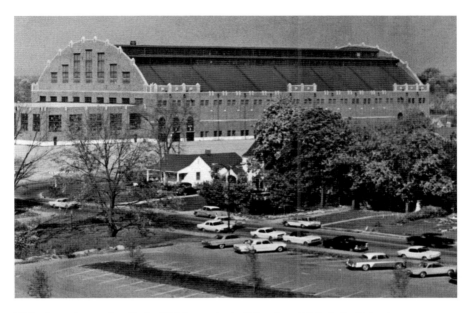

This photo shows what Butler Fieldhouse looked like circa 1950. *Butler University.*

O'Brien's playing time dropped below twenty minutes per game in 1952–53. The Olympians made the playoffs for the fourth consecutive season but ran afoul of the Lakers one last time. The team folded in 1953, and Indianapolis would be without an NBA team until the NBA-ABA merger in 1976, which brought the Pacers into the NBA fold.

THE MILAN MIRACLE

At this point, to tell the story of the Milan Indians, it has become necessary to disentangle reality from the fictionalized version of the Milan Miracle that hit the silver screen in 1986 under the title *Hoosiers.*

There was not and is not a town called Hickory, Indiana. The real heroes of the 1954 Indiana State High School Athletic Association tournament were from Milan, Indiana, a town of 1,150 residents. Located in the southeastern corner of the state, Milan is closer to Cincinnati, Ohio, than it is to Indianapolis, but it is 100 percent Hoosier in its appreciation for basketball.

Perhaps most notably, the Milan Indians were not coached by an outsider, let alone a temperamental former college coach in need of redemption.

Marvin Wood and the Milan Indians won the IHSAA title in 1954, proving that a small school could defy the odds. Their story inspired the 1986 film *Hoosiers*. *Milan '54 Museum*.

Marvin Wood was an Indiana man through and through, having played high school ball in Morristown and college ball for Tony Hinkle at Butler and taking his first coaching job at French Lick.

The film—which was never intended to be a documentary in the first place—got the soul of the 1954 state champs right, however. The Milan Indians drew their athletes from a tiny pool of local players who had little or no experience with anything but their rural upbringing. Their coach did have to lead them past bigger, more athletic teams to get them to the promised land. Rival coach Gus Moorhead of Versailles described the Milan style of basketball in *Milan, Indiana: A Storied Past*:

> *Under the tutelage of Coach Wood, they developed into a very sound fundamental basketball team that could play the Hinkle System on the half-court to perfection. They could fast break when the opportunity presented itself and they were very strong defensively. As the 1952–53 season progressed, they adopted a slow-down game dubbed the "Cat and*

Mouse" by a local sportswriter named Tiny Hunt. This Cat and Mouse game was a spread out three out and two down offense, a forerunner of the four corners, and was very effective in protecting a lead late in the game.

The so-called Hinkle System got the boys to the state semifinals in 1953, where they lost the afternoon game to South Bend Central. But that did mean that the Milan team, which returned largely intact the following season, had been to the big city and knew what it would take to return and claim the brass ring.

The team leaned into high expectations in 1954, scheduling tougher regular-season games against larger schools. Milan ripped off 8 straight wins but then lost a 49–47 nail-biter to Frankfort, owner of four prior state titles. Then came 10 more wins in a row. A 54–45 setback to Aurora was the only other blemish the team suffered, and it entered the postseason with a sterling record of 19-2.

The sectional tournament was played at Versailles. Milan whipped Cross Plains 83–36 and then faced the host school. Milan had already beaten the Versailles Lions three times that season, and it happily trounced them a fourth time and then beat Osgood to advance to the regional.

The regional was somewhat anticlimactic, beginning with an easy victory over Rushville. The second game, however, gave the Indians a chance to avenge an in-season loss to Aurora, which they did, winning by eight points to advance to the state semifinals at Butler Fieldhouse.

To the surprise of nearly everyone, Milan's first opponent in Indianapolis was even more of a small fish in a big pond. Tiny Montezuma, with a high school enrollment of just seventy-nine students, had somehow made it through to the elite group of sixteen teams vying for the state title. Milan was forced to play the unlikely role of Goliath, and it dutifully put down the Aztecs by a score of 44–34.

Milan's next game was truly one for the ages. The Indians met the Crispus Attucks Tigers with a state berth on the line. Attucks was a segregated, all-black school from Indianapolis. Not only were the Tigers playing in their hometown, but Attucks also played most of its home games in Butler Fieldhouse. The Tigers were bigger, stronger and faster as a rule, but they also had a star: then sophomore Oscar Robertson, who had already proven to be one of the best players in the state. Attucks had begun the season as a title favorite, but a series of injuries whittled away at the team's size and depth. Still, the Tigers, who had finished their season 17-4, had the potential to run the Indians out of the gym.

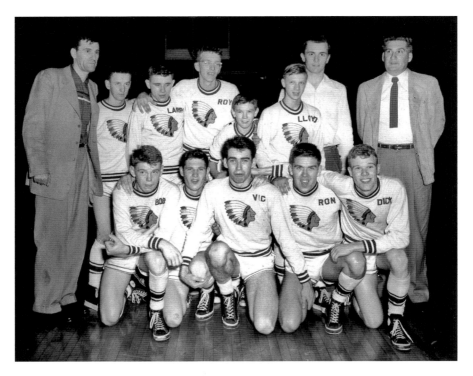

Milan beat many larger schools on its way to the 1954 title, but it also ended the dream of the Aztecs of tiny Montezuma High (enrollment of seventy-nine students) in a state semifinals matchup. *Indiana High School Athletic Association.*

In his autobiography, *The Big O*, Robertson told the true story of that game himself:

> *I can't honestly tell you that exhaustion had anything to do with what happened next. Milan had a strong team. They started fast and shot sixty percent in the first half and captured a comfortable lead. Bobby Plump shot the hell out of the ball and ended up leading all scoring with twenty-eight. I played okay, with twenty-two. Milan won by eight or ten and advanced to the state finals.*

Bobby Plump had plenty of respect for his opponent. He said later, "I'm glad we got him as a sophomore and not a senior."

Plump's shooting was rightfully legendary, but Milan won the state title as a team. The slowed-down cat-and-mouse style earned the team a 60–48 win over 1953 runner-up Terre Haute Gerstmeyer. Coach Marvin Wood

knew his team could win games with fewer possessions, and in the pre–shot clock days, that meant he could have Plump hold the ball for long periods of time. Gerstmeyer player Jack Smith grumbled, "It wasn't the best thing to go watch from a fan's standpoint." But Milan played the game according to the rules of the time, and it paid off.

One important thing to remember about the cat-and-mouse game is this: it was designed to protect a lead, which meant the Indians had to score points in order to put the stall into effect—theoretically, at least. In the final game against Muncie Central, Milan jumped out to a 14–11 lead in the first of four periods and increased that lead to 23–17 at the end of the first half. The Central Bearcats battled their way back against Milan's sticky defense and phlegmatic offense to snatch a 28–26 lead early in the fourth quarter.

Rather than panicking and rushing to regain the lead, Marvin Wood chose to stick to his guns. Bobby Plump crossed midcourt and stood like a statue, down two and seemingly happy to keep it that way. Nearly six minutes elapsed, with Muncie's players waiting and watching for Plump to make his move. The state title game film plays on a loop at the Milan '54 Museum in downtown Milan. You can leave the room, purchase some merchandise at the front counter, have a pleasant chat with the staff and return to see Plump standing exactly where you left him. "I was wondering what he was going to do with it," Muncie's head coach Jay McCreary said later. "We're two ahead and he's standing there holding the ball. If we were playing today, we would have put a little more pressure on them. In those days, you made them come to you."

Perhaps Plump's stall lulled the Bearcats to sleep. The Indians eventually went into their offense and scored a tying basket. Then they followed up with another made shot to take a 30–28 lead. Milan gave up a basket, and Marvin Wood called a timeout to set up a final play, one that almost resembles a modern-day NBA isolation play. Wood sent four Milan players to one side of the court and left Plump on the other side to take a final winner-take-all shot. Plump hit the shot, of course, and the "Mighty Men of Milan" were state champions. "We all hated it," said one Muncie partisan years later, "but it was the best thing that ever happened in this state."

The Milan Indians rode in fancy Cadillacs, loaned to them by a car dealership, from the field house to downtown Indianapolis. They were escorted by Indianapolis motorcycle policeman Pat Stark, who decided to take the team around Monument Circle against the normal flow of traffic as part of the parade. Nearly forty thousand fans followed the team caravan back to Milan, forming a miles-long traffic jam on the narrow road leading

The old water tower in Milan, Indiana, still sports the celebratory paint job it garnered in 1954. *Author's photo.*

to the town. Telegrams and letters of congratulation poured in from fans, both local and nationwide. A charming letter that Tony Hinkle wrote to Plump is on display at the field house, and Plump decided to continue his basketball career at Butler.

As the years passed, the legend of the Milan Miracle grew. First, it was a point of pride for small schools throughout Indiana, proof-positive that anyone from anywhere could earn that championship celebration if they worked hard enough. Then, it became a carrot for any team, large or small—the heart of the "if they can do it, so can you" speech any coach has in his arsenal. As the team itself became a black-and-white memory, the story came to represent the can-do spirit of Indianans in general. When Indiana natives Angelo Pizzo and David Anspaugh used the miracle as the basis of their film *Hoosiers* in the mid-1980s, they successfully transferred that sense of never-say-die pluck to a generation of moviegoers.

Bobby Plump's daughter Tari summed up the enduring appeal of the miracle: "I think the Milan story gives everyone hope that you can win against seemingly impossible odds. That's what life is about, right?"

GAME CHANGERS

The 1954 Milan Miracle is basketball-mad Indiana's most cherished hoops fable. What Oscar Robertson and the Crispus Attucks Tigers did one year later may be the greater achievement.

The story of the Milan Miracle is one great basketball yarn. A bunch of farm kids gathered up all of their pluck, gumption and native optimism and made an unlikely run to the Indiana high school state basketball title. It's the classic hero's journey, with a dash of David versus Goliath.

"That was the story that the local newspaper would pull out every year from the time that I can even recall being aware of what a high school tournament was," said Angelo Pizzo, who based his screenplay for the 1986 film *Hoosiers* on the tale he heard time and time again as a Bloomington, Indiana schoolboy. "They brought the story out to inspire the teams and create the type of mythology that would be inspirational enough for these schools to envision themselves being the next Milan."

To be the next Milan was the dream of every small school in the state. The Indiana High School Athletic Association imposed no classification system on basketball; tiny, rural schools with double-digit enrollment played in the same postseason tournament as urban powerhouses from Gary, Fort Wayne and Indianapolis. The sense that anyone, from anywhere could finish the season on top fueled the state's legendary hoops-mania, which became known as Hoosier Hysteria.

Each title-worthy team had to run a month-long gauntlet. The winnowing process began at the local level, as bitter local feuds were renewed in sectionals. If a team prevailed at that level, regionals came next. Win there, and your team moved into the rarified air of semistate, which often played out in legendary college venues at Bloomington, South Bend or West Lafayette. The pinnacle was the state finals, staged in the state's fifteen-thousand-seat basketball cathedral: Butler Fieldhouse.

Ironically, as of 1954, no team from the state's capital city had ever won the trophy that was handed out in its own backyard.

The word *sportsmanship* no doubt had a different connotation for white athletes than it did for players at Crispus Attucks, the only all-black high school in Indianapolis. Attucks opened its doors in 1927 in direct response to white citizens who had called for segregated facilities. Following an impressively self-serving Mobius strip of logic, IHSAA president Arthur Trester declared that Attucks was not a true public institution since it only accepted black students. He barred the school from his organization until

forced to give in to pressure in 1941. Even then, the Tigers struggled to play on anything remotely resembling a level field.

Willie Merriweather, who starred for the Attucks Tigers in the early 1950s and went on to become an All–Big Ten performer at Purdue, recalled his experience with high school officiating in the 2001 documentary *Something to Cheer About*: "[Our opponent] had a fast break, and I was closing off the lane. I had my foot on the out of bounds line and one foot was inside. The player dribbled right around me, around the out of bounds line, stepped on my feet and made a layup. The referee never called it. That's one incident I vividly remember because we would have got the ball back and probably won the game."

It would be natural for a competitive player to be livid at such a breach, to argue his case loudly and vocally. Black players in the 1950s didn't dare.

Fitzhugh Lyons, the man who first coached the Tigers, spent a great deal of time teaching his players what not to do, sometimes in language that was counterintuitive to a winning mindset. He instructed his teenaged charges to keep both feet on the ground when passing and shooting and to sag off of their opponents on defense. Nobody was to showboat, argue with referees or stand out in any way. In his autobiography, *The Big O*, Oscar Robertson was blunt: "Lyons selected his players more for their manners than their athleticism."

That changed when Lyons retired before the 1951 season. Ray Crowe, who had served as Lyons's assistant for two seasons, took the program in a different direction.

Crowe had been the only black player on his high school team in aptly named Whiteland, Indiana. In spite of the racial climate of the early 1930s, he was twice named team captain and led the team in scoring. Crowe later described the racism he faced in those days as "incidental." He lettered all four years at Indiana Central College and began his teaching career in 1938. He was hired as a teacher and assistant coach at Attucks in 1948.

Frustrated by his predecessor's seeming capitulation to the lose-with-dignity approach, Crowe took up the whistle intending to defy the soft bigotry of low expectations. He recruited tough, aggressive players and refused to rein them in. White officials—the only kind there were in Indiana high school basketball at that time—routinely made questionable calls against his team in close games. So Crowe taught his players to run and play tight man-to-man defense.

"Get a big lead and keep it," he told his players, "and the referees will play no role in the game."

Crowe's wife, Betty, described her husband's approach: "Ray was a hard taskmaster. He told them '9 times out of 10, when you go in there, you know the referee is going to be against you. So don't look at me when you get a bad call. Keep putting the ball in the basket. We get the first ten points for the referee, and then we start playing.'"

Crowe's approach worked. The Tigers, who had been absent from the state and semistate picture for years, lost just one regular-season game in 1951 and made it all the way to the tournament's final day before Evansville Reitz knocked them out in a controversial semifinal. Attucks stumbled in 1952 and then lost early at semistate in '53. In 1954, when Oscar Robertson began to grow into his role as a sophomore on the varsity team, the Tigers became one of the more notable victims of the slow-down tactics of eventual state champs Milan. Crowe's teams fell short of the title in each of his first four seasons as head coach, but the goal was in sight for the first time in the school's history.

The team's success made it more popular throughout the city, as a point of pride in their own neighborhood and as a coffer-filling curiosity for opponents. Teams that had never consented to play the Tigers before began to see that it made good financial sense to book games in Attucks's de facto home gym—the field house at Butler University.

"If you're going to play them at Butler Fieldhouse, you're going to split the gate receipts. It made sense to play Attucks because they drew ten thousand people every game," historian Aram Goudsouzian said. One of Crowe's players agreed, with a caveat: "Indianapolis benefited commercially. Butler Fieldhouse, especially, benefited commercially, because whenever we played there, it was full. So they benefited, and yet the benefit was not enough for them to say 'Yes, they can stay here and go to the cafeteria and eat.'" Attucks players were always whisked in and out of the venerable building as quickly as possible.

Fans of opposing teams weren't particularly welcoming, either. "My first time playing against [city rival Arsenal] Tech, I was a sophomore and we played them at Butler Fieldhouse," Robertson said. "Before we played them, I got a threatening phone call at home that said that if I played I'd be shot. My father heard me talking to them and asked me what was going on. He called the authorities and they had people around [at the game] but I think it was just someone trying to get us upset so we'd lose the game."

A record-setting ten thousand spectators crowded the field house for the game, which had become an embarrassing cause célèbre in the local newspapers, with anonymous threats and counter-threats flying between

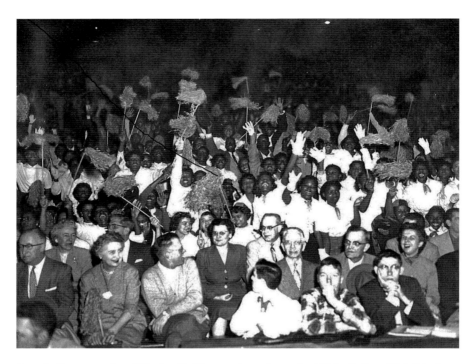

Attucks fans saw a lot of Butler Fieldhouse throughout the 1950s. *Indiana High School Athletic Association.*

supporters of the two programs. Attucks won the game, local cops made extra money patrolling the stands and nobody died. Still, the atmosphere in the city was tense.

By 1955, Oscar Robertson had matured into one of the finest players in the city, the state and most likely the nation, and he was surrounded by supremely talented teammates. Willie Merriweather shot an amazing 70 percent during the 1954–55 season and averaged a bruising twenty-one rebounds per contest. Bill Hampton, Sheddrick Mitchell and Bill Scott were returning veterans who knew how to thrive in Coach Crowe's up-tempo game plan.

Crispus Attucks entered the 1955 IHSAA tournament with a 21-1 record. The team's only loss had come at Connersville, where the weather, of all things, had slowed the Tigers' blazing attack. Robertson recalled that night in his autobiography:

> *The school's swimming pool was directly underneath the basketball court. It was an unbearably warm night and the gym was packed, and this made*

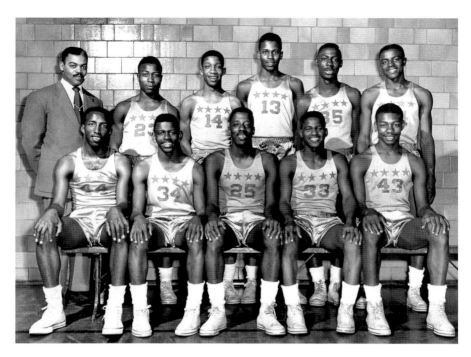

The 1955 Crispus Attucks Tigers were the first all-black basketball team to win a state championship in U.S. history. *Front row, left to right*: Sheddrick Mitchell, William Mason, Harold Crenshaw, Norman Crowe and Oscar Robertson; *back row, left to right*: head coach Ray Crowe, James Cornett, William Scott, Willie Burnley, Robert Jones and William Hampton. *Indiana High School Athletic Association.*

> *the place hotter and more stifling, so the windows and doors were open wide to try and cool off things. But right in the middle of the game, one of those low-pressure fields—the kind that Indiana weathermen still like to talk about—moved in. By the time the second half started, the temperature had dropped thirty degrees, and the Connersville floor had turned into a skating rink. Connersville was tough anyway—they'd opened up a good lead, and there was simply no way we were going to catch them while trying to run around that basketball court without skates on.*

The state tournament took place in March, in undeniably cold conditions, but the floor at the field house was famously well cared for. Attucks blitzed its first opponent, Wilkinson, by 53 points. A tougher Anderson team got off lightly, with a 25-point whipping in the regional final. The Tigers drilled Columbus by an 18-point margin and then eked

out a dramatic 71–70 win over Muncie Central, the previous season's second-place finisher, to escape the semistate round.

The state finals were played over the course of a single day in the 1950s. Roosevelt High, an all-black school from Gary, Indiana, started the festivities with an eye-opening 68–66 nail-biter over Fort Wayne North. Attucks dispatched New Albany in the afternoon session, 79–67. It would be Gary Roosevelt versus Indianapolis Attucks (in the shorthand typical of the tournament) for the state final, to be played that evening and broadcast to audiences across the state.

It is worth noting that a historical outcome was assured at this point. No state tournament anywhere in the United States had ever featured two all-black teams in the title game. Whichever took the crown would be the first "separate but equal" institution to ever win a high school basketball title. Any lingering racial bias in the refereeing corps was effectively neutralized. "The only time I ever relaxed was when we played Gary Roosevelt, because there were two black teams," recalled Attucks player Stan Patton. "So you figured it was going to be fair."

City pride may have actually tipped the atmosphere in favor of the Tigers. "It seemed like, at that time, the city was behind us," said Robertson teammate Bill Hampton. "Because they wanted a championship to come here."

Ray Crowe and his players were representing Indianapolis on the floor, but they were constantly reminded that their fellow citizens viewed them with suspicion and distrust. A beefier-than-usual police presence was called in to watch over the field house's windows, seats and fixtures as the two dark-skinned teams faced off. Oscar Robertson recalled that the crowd was eerily silent during warm-ups.

A story in the *Indianapolis Star* described the Roosevelt team this way: "The Panthers are fast. They pass well and unselfishly. Their rebounding isn't what it should be with all that height, but Wilson Eison is a real pro around the boards. As a unit, they're smooth, smart—a formidable foe for any team." Eison was named Indiana's Mr. Basketball in 1955; his presence made Roosevelt a dangerous match for Oscar and the Tigers. "We figured if we could just get to the final four that we could probably take it," Eison said.

Robertson described the start of the contest with precision in *The Big O*: "We won the opening tip, and I immediately took a pass at the top of the key, gave my quick fake, and took that one hard dribble—a move I'd been making since I was a child, a move I'd practiced tens of thousands of times. I pulled up for a sixteen-foot jump shot. The ball dropped through the bottom of the net."

Gary Roosevelt star Wilson "Jake" Eison (No. 11) was Indiana's Mr. Basketball in 1955, but he couldn't lead his team past Oscar Robertson and Crispus Attucks in the state final. *Indiana High School Athletic Association.*

The Tigers blanketed the Roosevelt Panthers with full-court pressure, forcing Eison and his teammates to fight for every inch of the ninety feet they needed to get from one basket to the other. Ray Crowe's team challenged every inbounds play and forced Roosevelt players to make dangerous passes by shutting down the dribble. The Attucks backcourt of Bill Hampton and Bill Scott made it their business to pester the Panthers immediately off of made baskets. Big men Merriweather and Sheddrick Mitchell consistently beat everyone back on defense in the event of a rare Attucks miss.

Roosevelt double-teamed Oscar Robertson, and when that didn't work, they occasionally triple-teamed him. It made no difference. Robertson scored thirty points in the final game. Eison actually eclipsed that mark, pouring in thirty-two in a heroic effort. Robertson likes to point out that he had a chance to tie Eison late in the game but passed up a jump shot and whipped a pass to seldom-used reserve Willie Burnley, who scored a basket he'd never forget.

Legendary coach Ray Crowe celebrated with his team—which included Oscar Robertson (second from left)—after winning the sectional in 1955. There would be bigger victories to come. *Indiana High School Athletic Association.*

"It's over, and Indianapolis wins their first state basketball championship!" came the call from the television announcer as the final horn sounded. Crispus Attucks claimed the state title with a convincing 97–74 win. Pandemonium erupted as the final seconds ticked off of the clock. "It was the best, most pure feeling I've had in my life," Robertson wrote, nearly fifty years later.

The celebration continued. It was customary for the title-winning team to board a city hook-and-ladder truck for a triumphant parade through the streets. Bobby Plump, who had shot the Milan Indians to the title one year prior, remembered the thrill of the truck stopping at Monument Circle for speeches and more whooping and hollering in the heart of the city. When the truck bearing the Attucks players circled the massive, 284-foot Soldiers and Sailors Monument once and then motored away without stopping, Robertson's pure feeling began to take on a bit of tarnish.

An elderly Ray Crowe described what happened next with some equanimity when interviewed for *Something to Cheer About*. "They took us around Monument Circle downtown and then back out to Northwestern Park, to have a big bonfire and celebrate there," he recalled. "Northwestern Park was in a black

neighborhood. I guess that's just part of the feeling whites had. 'Let 'em do their own thing in their own neighborhood.'"

Ecstatic supporters of the team didn't pay much attention to the slight. Members of the Attucks team were oblivious to the fact that the routine had been changed for them. Only the ever-mindful Oscar Robertson noticed. "I guess the people who ran the city thought that, being black, we'd tear up the city, that we'd be different than any other team that won," Robertson mused, decades later. "Things like that you just can't forgive people for. I don't."

Nonetheless, the championship victory was a watershed moment for black citizens of Indianapolis. The Crispus Attucks Tigers had displayed toughness, unity and discipline in achieving their landmark success. They had placed a kernel of doubt in the minds of those who would deny the possibility of black excellence and planted a seed of hope in the hearts of their neighbors in the Naptown ghetto.

The city that had gained so much from the Tigers' exceptional season did begin to show signs of change following the 1955 season. Members of the team, and then other black citizens, were welcomed at downtown restaurants that had once denied them service, seemingly in direct response to Attucks delivering a title to the city.

Coach Ray Crowe led his Tigers back to the state title game in 1956, where the team made history again, becoming the first undefeated state champion in Indiana history. Crowe's back-to-back title teams lost just one game in two years. He led the Tigers back to Butler Fieldhouse for a title-game loss in 1957 and then hung up his whistle to become the school's athletic director. In 1967, he was elected to the Indiana House of Representatives, and he later served on Indianapolis's city council and became director of the city's Parks and Recreation Department. He appeared in *Hoosiers* as the opposing coach in the state final, taking a familiar seat in Hinkle Fieldhouse once again. When Crowe died in 2003, another of his legendary former players, Hallie Bryant, enumerated his teacher's strengths: "Firm, fair, flexible and frank."

His excellence as a basketball coach was an organic part of his fundamental integrity as a human being. "Mr. Crowe became our coach, our mentor, our father," said Merriweather. "He made us believe in ourselves, and together we changed the game of basketball."

The extraordinary success of the Crispus Attucks Tigers may have changed much more than the game of basketball. Maxine Coleman, a cheerleader at Attucks in the 1950s, hinted at a more enduring legacy of the team's glory years.

"We didn't think of ourselves as black," she recalled in 2001. "We just thought of ourselves as very, very good."

Butler Likes Ike

President Dwight David Eisenhower had a busy day on October 15, 1954. He flew out of Lowry Air Force Base in Denver at 12:34 p.m. MST and arrived in Indianapolis at 5:34 p.m. local time. He departed the city at 9:10 p.m. bound for Washington, D.C. In the three hours and thirty-six minutes between flights, he found time to speak before the National Institute of Animal Agriculture in Butler Fieldhouse.

Tickets for the event called it "Ike's Birthday Party" though the president had actually been born on October 14, 1890.

The former supreme commander of the Allied forces in World War II had grown up on a farm in Kansas, so he knew what to say to those assembled.

"Now, my principal purpose this evening is to give you an account of this administration's stewardship in matters specially affecting our agricultural community," the president said in his opening statements. "In doing so I do not mean to imply that our farmers' interests are limited to farming. Far from it! The welfare of 163 million Americans is bound up with our Nation's agriculture—just as every farmer is affected by all national and world affairs."

The nation was then in the throes of the red scare, and the president felt obliged to allude to the specter of communist infiltration in his speech.

"Our farmers, as all of us, want a trustworthy government—a government that deals quickly and effectively with those in its employ who are unfit, or corrupt, or tinged with communism. Misfits are being tirelessly searched out and removed from sensitive government positions. New laws passed by the 83d Congress have powerfully strengthened the efforts of the Department of Justice and the FBI to deal with the Communist menace in our country."

The president's remarks drew a stark contrast to feelings he had expressed privately following an earlier visit to the field house. In 1952, as a Republican candidate, Ike had stumped for votes at the field house. On that occasion, he was dismayed to learn that he would be introduced by Indiana senator William Jenner. Jenner was hoping to gain Ike's endorsement for his own reelection campaign, but remarks the senator had made on the Senate floor in 1950 still rang in Eisenhower's ears. Jenner had called General George Marshall "[a]

President Dwight D. Eisenhower spoke to the National Institute of Animal Agriculture inside Butler Fieldhouse on October 15, 1954. The event was billed as "Ike's Birthday Party," though the president's actual birthday was one day earlier. *Butler University.*

front man for traitors…a living lie…an errand boy, a front man, a stooge or a co-conspirator for this administration's crazy assortment of collectivist cutthroat crackpots and Communist fellow traveling conspirators." Quite aside from his egregious abuse of alliteration, the senator had insulted the character of one of Eisenhower's most respected military colleagues.

As the Republican nominee in 1952, Eisenhower did not feel comfortable openly distancing himself from a fellow Republican. In *Eisenhower: In War and Peace*, author Jean Edward Smith described how the nominee handled his unpleasant duty during the 1952 visit to Butler:

> *Eisenhower said he decided to run because he could not sit by while his country was "the prey of fear-mongers, quack doctors and bare-faced looters." At every sustained burst of applause, Jenner reached out and raised Ike's arm aloft as if designating the winner in a prizefight. When Eisenhower concluded, he asked support for the Republican ticket in Indiana*

"from top to bottom," in effect endorsing Jenner but not by name. The Indiana GOP leadership was disappointed Eisenhower did not mention Jenner, but settled for half a loaf. Jenner leaped up and embraced Ike in a bear hug, flashbulbs recorded the scene for the morning papers, and Ike gritted his teeth. "Charlie, get me out of here," he commanded Congressman Charles Halleck, the Republican whip in the House of Representatives, and they left the platform before anyone knew what had happened. "I felt dirty at the touch of the man," Eisenhower told Emmet Hughes.

If the reality of party politics ran counter to Dwight Eisenhower's personal feelings, he did not let it show openly when he appeared at Butler Fieldhouse.

END OF AN ERA

Billy Shepherd, who would one day star on the field house floor, attended several of the important high school games of the 1950s as a child, including the Milan Miracle and the Attucks repeat titles. In a 2014 interview, he reminisced about the feeling of being a young boy in the legendary cathedral of basketball:

When I was growing up, they had a net across the end of the field house about five feet extended beyond the end line so people wouldn't walk into that part of the court or the ball wouldn't go into that area. They also had some little baskets that sat on the back of the backboard where the Butler players would shoot free throws during practice. That was before they brought in the portable goals out for practice. So every now and then in warm-ups if a ball would slip over there, you could shoot it over the net into the side basket, so to speak.

It was the first of many baskets the budding basketball star would make in Butler's jewel of a basketball arena.

In 1958, Tony Hinkle called for a change in the standard basketball. He worked with the Spaulding Company to create an orange ball that was easier to see from the stands. The ball was used at the 1958 NCAA finals for the first time, and the new ball became standard.

Also in 1958, Crawfordsville made a memorable run to the state finals. A member of Crawfordsville High's class of 1958 recalled the thrill of visiting the field house. "The day of the big game, a group of my friends gathered at

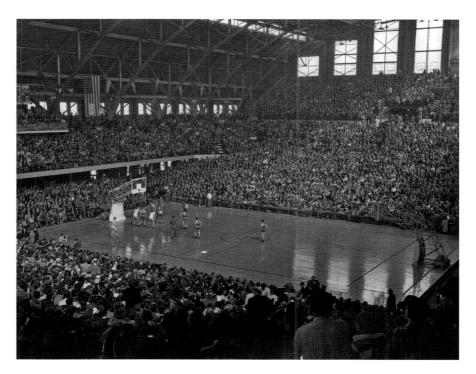

Hinkle Fieldhouse was full to the brim with high school basketball fans in 1963. *Indiana High School Athletic Association.*

my house for the trip. We were all adorned very well in gold and blue," she said. "When we arrived at the field house, I remember thinking about how huge it seemed. We were playing Muncie Central [in the semifinal]. The worst moment came when Dick Haslam had to leave the game due to an injury. When we won that game, we were deliriously happy!"

Crawfordsville lost in the final to Fort Wayne South Side; however, Haslam won the Trester Award, and the team was fêted by the hometown fans upon its return. Haslam went on to a four-year career as a Butler Bulldog under Tony Hinkle and played in the NCAA tournament.

The high school basketball scene began to change throughout the state in 1959, with the passing of the Indiana School Reorganization Act. At the time, more than one-third of Indiana's high schools enrolled fewer than one hundred students. The move to larger schools with a more concentrated enrollment may have made allocation of resources easier, but it eliminated several of the smaller schools that had carried the hopes of entire towns on their backs every winter.

WHAT'S IN A NAME?

The final Hoosier Classic was played in the 1960–61 season. Indiana University had withdrawn from the series, so Illinois filled in as the fourth member of the field, alongside traditional participants Purdue, Butler and Notre Dame. Tony Hinkle's club beat the Illini and Boilermakers, but the final event drew just 6,100 spectators and was discontinued.

The Bulldogs finished that season 15-11. They were champions of the Indiana Collegiate Conference but were not invited to a postseason tournament. That was about to change.

FIRST NCAA BID

With all five starters returning from the previous season, Butler's basketball team was expected to excel. However, it was a newcomer to the varsity team who made the most waves. Jeff Blue had been a highly regarded player for Bainbridge High School in the Greencastle area. Jeff's older brother Mike played freshman basketball for Tony Hinkle, and that mattered more to Jeff than all of the outlandish promises other schools made during the wooing process.

In fact, it was precisely Tony Hinkle's honesty and integrity that won Blue over. Several coaches from the nation's top programs had traveled to visit Blue and ply him with dubious promises. Hinkle, on the other hand, asked

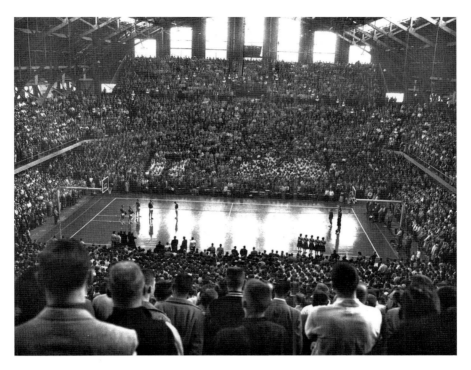

Fans had a spectacular view from any seat in the house during the 1963 IHSAA basketball tournament. *Indiana High School Athletic Association.*

Blue to come to him. Howard Caldwell related the particulars of Hinkle's low-key recruitment tactics in his biography of the coach:

> *Blue's interview took place on the lower level of the fieldhouse in the equipment room. He sat on the edge of an old wooden desk and Tony sat in an old rocking chair. The conversation lasted about ten minutes. Blue said Hinkle told him he thought he'd like it at Butler, that he'd fit "our brand of basketball," that no effort was made to create a star, and that a scholarship included tuition, books, room and board and nothing more. Blue thought, "Gosh, it's a good thing I want to go here." Just as he was leaving came this comment from Hinkle: "Now, if you decide you don't want this scholarship we're offering, you be sure and let me know because we don't want to cheat some other kid out of it."*

Jeff Blue played with the freshman team in the 1960–61 season. His talent was evident, but the NCAA would not embrace freshman eligibility until

1972. So Blue paid his dues, worked hard for Pop Hedden and arrived on the varsity team as a sophomore, ready to prove his mettle.

There was one small hitch, however. Blue had been ordered to report for a military induction physical, despite the fact that he had filed for educational deferment. Blue got this news just hours before Michigan was scheduled to pay a visit to the field house, so Tony Hinkle got on the phone and straightened the mess out quickly. Hinkle never let Blue forget it, either. Caldwell explained:

> *At practice the following week, nothing was going right. Mistakes were erupting thick and fast. Blue said that at one point he turned to drive toward the basket when he bounced the ball off his foot and out of bounds. Hinkle, who was sitting on a basketball at the edge of the floor, threw his hands in the air, lost his balance, fell off the [raised] floor and onto the concrete. Everything went stone silent except for Blue, who burst out laughing and couldn't quit. Hinkle approached, his scowl set, to within ten feet of Blue, then said, "Blue, I should have let the military have you."*

For better or worse, Butler University had Blue—mostly for better, as it turned out. The Bulldogs beat Michigan with the properly deferred Blue in the lineup and ended Bradley University's seventy-one-game home winning streak in Peoria. They won, home and away, against Notre Dame, with Blue scoring twenty-six points in South Bend.

The Bulldogs finished the season with a 21-5 record and earned a spot in the twenty-five-team NCAA tournament field. It was a first for the program. The team traveled to Memorial Coliseum in Lexington, Kentucky, for its first tournament game.

Their first opponent was Bowling Green, the number eight team in the nation. The Falcons literally and figuratively revolved around six-foot-ten center Nate Thurmond, and the team deployed a tight zone defense in an attempt to stymie Blue's shooting touch. The strategy worked for most of the game, but Butler's Tom Bowman and Gerry Williams shot well enough to make up for Blue's struggles. The Bulldogs took a late lead on a couple of free throws and then defended well enough to keep Bowling Green from scoring again in the final sixteen seconds of the game. Tony Hinkle and Butler had earned a dramatic 56–55 NCAA tournament victory.

The team's reward was to travel to Iowa City four days later to face Kentucky, ranked number three and coached by Adolph Rupp. Blue and his teammates fought hard, but the Wildcats cruised to a twenty-one-

Butler traveled to Memorial Coliseum in Lexington, Kentucky, to play Bowling Green in 1962. It was the team's first ever National Collegiate Athletic Association (NCAA) tournament appearance. *Author's photo.*

Hinkle's floor has seen decades of high school basketball action. *Indiana High School Athletic Association.*

point victory. Hinkle's team completed a sort of bluegrass trifecta the next evening, earning a one-point overtime victory over Western Kentucky in a consolation game.

That 22-6 mark was the best of Tony Hinkle's distinguished career. It was also his only appearance in the NCAA tournament as a head coach.

In the 1961 high school title game, Kokomo defeated Indianapolis Manual in the final game. It was an overtime thriller that ended 68–66. Twin brothers Dick and Tom Van Arsdale ended up on the losing side of that battle, but both brothers had more to offer their home state on the court. The twins showed incredible synchronicity in that summer's Indiana versus Kentucky All-Star games, scoring 26 points apiece at Freedom Hall and 14 each when the series concluded at Butler Fieldhouse. Both brothers went on to star at Indiana and have multiyear NBA careers, playing together again for the Phoenix Suns in 1976.

The Rocket

Basketball history runs bone-deep in Lebanon, Indiana. The local high school fielded its first official team in 1907. In 1911, when the Indiana High School Athletic Association first sanctioned the tournament that would evolve into Hoosier Hysteria, Lebanon was runner-up to local rival Crawfordsville. The Tigers rectified that galling loss the very next season, taking the 1912 state title with a stunning 51–11 demolition of Franklin. Over a two-season arc starting in 1916 and ending in 1918, Lebanon went 54-4 and won back-to-back state championships.

John Porter, who scored an outlandish (for the time) twenty-six points in the 1912 title game, went on to become a doctor in his hometown. On January 5, 1947, Dr. Porter delivered a baby boy who would grow up to become the most famous basketball player Lebanon had ever produced. The child was christened Richard Carl Mount. Eventually, the boy would come to be known as Rick. When his transcendent basketball talent made him the toast of Indiana high school basketball in the mid-1960s, Rick adopted the nickname "Rocket."

Rick grew up playing in the tiny Lebanon gym, which seated just 2,200 of his closest friends and neighbors. It was, perhaps, a sign of changing times that the white youngster from a rural town modeled his game after a black athlete from the big city of Indianapolis, as told by Frank Deford in a 1966 *Sports Illustrated* cover article:

Comparisons are obligatory because Oscar Robertson played in high school just 26 miles away, down what is now Interstate, in Indianapolis, and many people have seen them both. When Rick was just a sophomore Ray Crowe, Oscar's coach at Crispus Attucks High, said: "At this stage he's as good as Oscar was." Most fans, like Pistol Sheets, who runs the town pool hall, agree with this analysis. Pistol expresses the consensus this way: "Rick is a better shooter than anyone you ever saw in high school, but Arsker"—that's the way they pronounce Oscar in Lebanon, Ind.—"now Arsker, he had the better maneuverability."

Rick "Rocket" Mount became a national cause célèbre when Frank Deford profiled him for *Sports Illustrated* in 1966. The deadeye shooter from Lebanon, Indiana, went on to star for Purdue. *Author's collection.*

Rick Mount was roughly the same height as his idol, and his fame, which began to grow exactly one decade after Oscar's high school exploits electrified the state, drew plenty of attention. Rocket averaged 23.6 points per game as a sophomore and 33.1 as a junior. His numbers continued to go up in 1966 as the Tigers dreamed of going to Indianapolis and winning a state title of their own.

Rick Mount was naturally ambidextrous, which made him harder to guard. His high-arching shot had famously been developed by his father, who cut the bottom out of a peanut can and had Rick practice shooting a tennis ball into the narrow cylinder. Rick shot around 80 percent from the free-throw line and 50 percent from the floor. He could hit from anywhere in the halfcourt and would have no doubt thrived behind the three-point line if it had been in use. He could dribble and pass and even step into the pivot in a high school game.

All of the big-time programs wanted Rick Mount. He got personal visits from Duke's Vic Bubas and legendary Kentucky coach Adolph Rupp. Even John Wooden consented to meet with the young phenomenon from his home state, though the reigning national championship coach made Mount come to him as he waited at the Indianapolis airport and never overtly asked him to come to UCLA. Mount recalled that Wooden talked mostly about how he expected zones to collapse on Lew Alcindor in upcoming seasons, which would certainly have appealed to a shooter of Mount's caliber.

In fact, Mount came very close to meeting and playing against Alcindor in a high school game in 1965. Miami head coach Bruce Hale, who also had his eye on Mount, attempted to set up a marquee game with the help of Lebanon head coach Jim Rosenstihl, as recounted in *Indiana High School Basketball's 20 Most Dominant Players*:

> *Rosenstihl enjoyed promoting basketball, and Hale helped him schedule a game at Butler University against New York City's Power Memorial High School and its famed seven-foot center, Lew Alcindor. IHSAA commissioner Phil Eskew gave his blessing, and thousands of tickets were sold. It was being billed as the mythical national championship contest.*
>
> *However, just a few weeks before the game was to be played, a story appeared in the* Indianapolis Times *that questioned why Lebanon—and no other Hoosier school—was able to play a game of this magnitude against a team from a faraway state.*
>
> *"Phil Eskew kind of lost his backbone and canceled the game," Mount said. "It would have been a great game. It was sold out. Rick Mount vs. Lew Alcindor. We were ready to play the number-one team in the nation."*

If the field house has mystique now, imagine what a visit from young Lew Alcindor would have added.

Mount did get his chances to play in the famous building, which was renamed in honor of Tony Hinkle in 1966. That year, Mount's senior

Rick Mount played alongside several other well-known college players from around the country when the 1970 East West College All-Star Game was hosted at Hinkle Fieldhouse. *Author's collection.*

season, Lebanon played archrival Crawfordsville at Hinkle Fieldhouse, and ten thousand people showed up to see him play. It was technically a home game for Crawfordsville, but the Athenians had moved their half of the in-season home-and-home to the university, in hopes that the larger capacity of the field house would bring in enough ticket money to replace the team's worn-out bus. The gamble paid off: Crawfordsville earned enough to buy a brand-new Greyhound. Lebanon shared in the financial profit and won the game to boot. And the Rocket scored fifty-seven points.

Dick Haslam, who coached that game for Crawfordsville, recalled that game fondly. Haslam had thrilled field house crowds himself as a high school star and four-year Butler player, but even he admitted that "Rick Mount was the star attraction."

Mount also played in the 1970 East West College All-Star Game following his senior season at Purdue. The game was played at Hinkle Fieldhouse, where fans cheered excitedly for the local boy who had already signed with the Indiana Pacers.

Honoring Tony Hinkle

In 1966, Butler University's trustees elected to rename Butler Fieldhouse in honor of the coach who had built the school's basketball, football and baseball programs. The name change to Hinkle Fieldhouse was made with surprisingly little fanfare, though the new name was mounted on the monitor level in large block letters.

Tony Hinkle was his typical humble self when informed of the name change. "Naturally, I'm very happy they think I've done something to warrant such an honor," he said. "I'll try to live up to what the trustees think of me." It wasn't the only recognition Hinkle would receive that year—he was also named to the Naismith Basketball Hall of Fame.

In 1966, the Michigan Wolverines, led by superstar wing Cazzie Russell, came calling at Hinkle Fieldhouse. Not many gave the typically plucky Bulldogs much of a chance in that one. Michigan coach Dave Strack recalled how physically dominant Russell was in that game.

"I believe the first dunk I saw anybody take in competition was Cazzie at Butler," Strack said later. "He beat his man and slammed that damn thing through. I said, 'Oh my goodness gracious what was that?'"

LETTERMEN --- (Front row, l-r) Doug Wininger and John Nell. Back row - Garry Hoyt, Gary Cox and Bill Mauck.

Butler's returning lettermen faced a schedule loaded with powerful foes in 1967–68. Tony Hinkle scheduled Illinois, Oklahoma, Michigan State, Purdue and Ohio State that season. *Author's collection.*

Russell's heroics aside, the Hinkle Magic came into play. The Bulldogs mysteriously out-rebounded the Wolverines and came away with a huge 79–64 win over a team that sat atop the national polls.

ALL-STARS

As the decade drew to an end, the American Basketball Association (ABA) showed interest in holding its first-ever All-Star game in Indianapolis, specifically at Hinkle Fieldhouse. Butler officials, still smarting over the scandal that had tainted the Indianapolis Olympians, were initially disinclined to grant the petition. City boosters argued that it was a huge opportunity to showcase Indianapolis and the field house, and their argument eventually won out.

As a result, the ABA All-Star game was played in Hinkle Fieldhouse on January 9, 1968, in front of a crowd of 10,872. The East team was coached by Jim Pollard of the Minnesota Muskies. The West coach was Babe

McCarthy of the New Orleans Buccaneers. The eastern conference won the game, 126–120, led by 22 points and fifteen rebounds from Muskies star Mel Daniels. It was a player from the losing team, future coaching legend Larry Brown, who took the MVP honors, however. Brown, representing the Buccaneers, hit seven of nine shots from the floor, including two 3-pointers.

This promotional fan was issued by the *Indianapolis Star* to promote the annual Indiana versus Kentucky All-Star game. Every summer, high school stars from each state played a two-game series, with one game at Freedom Hall in Louisville and another in Hinkle Fieldhouse. *Author's collection.*

The IHSAA tournament brought more thrills to the end of the decade, as Indianapolis Washington made an undefeated run to the state title. Star forward George McGinnis had always dreamed of playing that game in the field house. Growing up in the city, he and his friends would sit in the field house parking lot some days and imagine what the radio play-by-play announcer would say if Washington won a championship.

"That's how big the dream was for us and that's what it meant to us," McGinnis said. "There's just something about that building that's so unique, so special. You feel it."

McGinnis's exploits in the state finals, alongside his 32.7-point-per-game average over the length of his senior season, earned him the title of Mr. Basketball and an opportunity to participate in the Indiana versus Kentucky All-Star game. McGinnis shone in the first game of the two-game series, scoring 23 points to go with fourteen rebounds in front of a thrilled crowd at Hinkle.

Before the series moved across the border to Freedom Hall for the rematch, Kentucky All-Star Joe Voskuhl made the unwise decision to poke the bear. "I think he's overrated, I really do," Voskuhl said to the *Louisville Courier-Journal*. "Oh, he's good, but he's overrated."

Big mistake. McGinnis used and abused Voskuhl on his way to a 53-point, thirty-one-rebound performance that hushed both Joe and the pro-Kentucky crowd. The resulting 114–83 win gave the Indiana All-Stars a sweep and put an exclamation point on a perfect season for George McGinnis.

7

ALL GOOD THINGS MUST END

As the 1970s dawned, the game of basketball was speeding up. There was no shot clock yet, but mop-topped young men were scoring as quickly as possible regardless. It was up to coaches to figure out how to balance this offensive-minded eagerness with enough defensive discipline to win games.

HINKLE'S LAST GAME AND RETIREMENT

The fortunes of the Butler Bulldogs had been somewhat unpredictable throughout the 1960s. In the 1960–61 season, Tony Hinkle's team went 15-11 and garnered the Indiana Collegiate Conference title. The next season, it won the league again and played in the NCAA tournament. Following that very successful season, the Bulldogs muddled through the rest of the decade with 87 wins and 94 losses. While nobody would dream of boiling Tony Hinkle's worth down to wins and losses alone, the basketball program was struggling to win consistently.

Even so, it was a surprising and unpopular decision when the university announced that Tony Hinkle would be forced to retire following the 1969–70 season. He had reached the school's mandatory retirement age, but it was clear that he still had plenty of vigor and desire for coaching. No less a Hoosier basketball legend than John Wooden decried the decision, saying,

"College athletics will have lost just a tremendous person. No, not just as a coach. He is tremendous there, too, but so much more. Tony is a great, warm person and always has been. I'll always feel just the association with him has helped me." Nonetheless, his official retirement date was set for August 1, 1970. It would be a season of lasts for the legendary coach.

His last football game went well. His gridiron charges carried him off the field on their shoulders following a season-ending 38–20 victory over in-state rival Valparaiso. His basketball team began the season hoping to give him a similarly memorable finale in the field house that bore his name.

The group that took the floor in late 1969 was different than any Tony Hinkle had ever coached. The "Butler Way" was predicated on fundamentals and staunch defense, which was somewhat at odds with the floppy-haired, trigger-happy group of greyhounds he had assembled. The team's powerful offense was, more often than not, funneled through the hands of sophomore Billy Shepherd. Shepherd's father had played for Hinkle in the post–World War II years, and those family ties had helped bring the supremely talented teen, who had been named the state's Mr. Basketball in high school, into the Butler program.

In a 2014 phone interview, Shepherd recalled that, talent and reputation aside, he knew he would have to work hard and prove his worth to Tony Hinkle. He made a strong first impression in 1968–69 as a member of the freshman team in hopes of earning more playing time in his sophomore season.

"Back then the freshman team scrimmaged the varsity team, and that was the intrasquad game. My freshman year, we actually beat the varsity in a forty-minute game. I was confident that I could play as a sophomore, but I didn't take that for granted. I knew I'd have to work hard."

Shepherd and his teammates were clearly able to score. They were not particularly patient on either end of the floor, however. Hinkle told biographer Howard Caldwell that it took him some time to get accustomed to running a stable of Thoroughbreds that season. "Their game was run and shoot and it took me a while to learn that. I tried to slow 'em down at first… and I found out that when you slow these guys down, they stop."

Hinkle didn't simply roll the ball out and cover his eyes that season. Shepherd remembered his coach handling him with patience and a liberal dose of tough love. "Coach Hinkle had a 'jackass trophy' that he kept in the locker room for the player who made the most mistakes in a ballgame. The first five or six games of my sophomore year, that trophy had a permanent position on the top of my locker. After that I got the hint and stopped trying to make crazy passes and made the ones I knew the guys could catch."

14- BILLY SHEPHERD G 5-10 160 Sr. Carmel, Ind.

SPORT calls him one of the best guards in the land. Several other national magazines echo those sentiments. Ranked among the top 20 scorers in the nation as a sophomore and 26th last year as a junior. He has averaged 27.8 and 24.0 in his two varsity years as a Bulldog. Broke an Arizona gym record last year with 49 points, and a number of other Butler marks--including the two-season scoring and most free throws in a single season. The ex-Carmel ace ranks among all-time leading scorers in Indiana high school history with Rick Mount, Oscar Robertson and George McGinnis. Was Indiana's "Mr. Basketball" in 1968 and also a high school All-American the same year. Coach Theofanis believes Shepherd can handle and pass the ball as well--maybe better--as any guard in the country. Has scored 1,347 points in two years--fourth highest in Butler history--and is a virtual cinch to break the all-time mark of 1,439 points. Wants a crack at pro ball.

His Record:	G	FG	PCT	FT	PCT	PF	R	TP	AVE.
1969-70	26	287-652	.440	150-200	.750	42	78	724	27.8
1970-71	26	226-579	.390	171-222	.770	55	83	623	24.0

Billy Shepherd thrived in an up-tempo attack in the 1970 season. He scored thirty-eight points in Tony Hinkle's final game as head coach. *Author's collection.*

When Shepherd and his teammates stopped turning the ball over, magic happened. The Bulldogs shot extremely well, hitting a smidge under 50 percent from the floor and a solid 72 percent as a team at the free-throw line. Their accuracy was impressive, especially considering whom they played during Hinkle's farewell tour. The Bulldogs took four tough losses right out of the gate that season as they ran a gauntlet through Illinois, Ohio State, Purdue and Western Kentucky.

"[Tony] Hinkle back then was really known for beefing up the schedule," Shepherd said. "My sophomore year I know Michigan State came in and played us. We played nine of the ten Big Ten schools on our twenty-six-game schedule."

The season began to turn around (possibly around the time Shepherd became determined to divest himself of the jackass trophy) following an 85–69 victory over Idaho State that was described as a "precision lesson." Local newspapers praised the team's next win—a 21-point drubbing of visiting Michigan State—as "a painful lesson in fundamentals" for the visiting team. Tony Hinkle's diminutive backcourt of Steve Norris (five feet, eight inches tall) and Shepherd (five feet, nine inches tall) was beginning to find a rhythm.

"I think that what Hinkle did was he adjusted a lot to the talent, to the personnel that he had," Shepherd recalled. "Steve Norris averaged eighteen as a junior, and when I came in as a sophomore, he was a senior. Norris sacrificed a lot his senior year because he became more of a point guard and an assist man. He still averaged sixteen, but a lot of my teammates made sacrifices so I could score."

Against stiff competition, nothing came easy. The Spartans were the only Big Ten team to fall to the Bulldogs, and several other teams stole wins from Tony Hinkle's last team. Hinkle himself took the blame for a loss to St. Joseph's in the season's penultimate contest. "We were leading by two," Hinkle told his biographer later in life, "and I told 'em if St. Joe scored to take the ball to midcourt and then call time, and we'd set up a play. I should have known enough to let them run and shoot." Operating off the set play, the Bulldogs turned the ball over and lost on a last-second shot. "I masterminded 'em out of that one," Hinkle said.

However it happened, the team entered its final game of the season and its final game under Hinkle's command with a 15-10 record. There would be no postseason bid, but the season finale would have a playoff-like atmosphere for several reasons. Not only was Tony Hinkle going to say farewell, but also the final opponent was a high-octane Notre Dame team, led by superstar guard Austin Carr. At six feet, four inches and two hundred

pounds, Carr could run and score with anyone, and he would be a major handful for Butler's smaller guards.

Butler Fieldhouse had been renamed in honor of Tony Hinkle in 1966. The building's official capacity was fifteen thousand souls, and the basketball team's media guide records that exact figure as the attendance record, set on the night of Hinkle's final game. Perhaps that number was chosen to please the fire marshal because Shepherd recalled that "they were standing four and five deep that night up around what I call the 'wraparound' at the top of the fieldhouse."

Butler students, staff, fans and former players stuffed the

Austin Carr outdueled Billy Shepherd in Tony Hinkle's last game in the field house named in his honor. *Notre Dame Athletics.*

building to pay tribute to the man who had epitomized the Butler Way since 1926. The field house had officially opened in 1928 with a 21–13 win over Notre Dame, and the assembled fans no doubt hoped for a similar outcome, though the scoring totals could reasonably be expected to quintuple.

Tony Hinkle arrived for his final basketball game wearing his standard coaching attire: gray flannel pants, blue blazer and white athletic socks. Legendary local broadcaster Tom Carnegie was the master of ceremonies, and he began his remarks with a warm salutation.

"You have your wish, Tony! The field house named in your honor is full tonight," Carnegie intoned. Then Carnegie lightened the tone, ribbing his old friend on his wardrobe. "White socks are not exactly the 'in' thing," he joked, "but we know why you wear them. You pick them up in the equipment room for free." An Indianapolis clothing store then presented Hinkle with a full new wardrobe, which no doubt took some of the sting out of the teasing.

Next up was Tony's friendly rival, Notre Dame athletic director Moose Krause. Krause presented a huge blanket emblazoned with the Notre Dame logo and then got down to serious business. The Notre Dame Alumni Club had given Coach Hinkle an all-expenses-paid trip to Hawaii as a going-away present. Butler's president, Alexander Jones, handed Tony a large scrapbook brimming with telegrams and letters from Butler alumni throughout the nation.

When it was Hinkle's turn to speak, the crowd grew hushed. "I'd like to think I've given as much to Indiana, to Indianapolis and to Butler University as they've given to me," he said. "Let's make it a happy occasion and hope we have a good game." Short, sweet and simple as always.

As the game got underway, Austin Carr knew he would receive special attention.

"All teams would double-team or triple-team me," Carr recalled in 2014. The Bulldogs were no different in that respect, but the contest was heavily weighted toward offense in spite of their efforts. "It was a fast-paced game, going up and down the floor. Shepherd was shooting it from all over the place. He was scoring from halfcourt almost."

"I always tell Austin if we had had the three-point line we might have beat them that night," Shepherd said.

On a night when everyone on the floor seemed to be raining in shots, Carr's effort stood out. He slashed into the lane for layups, and when his defender sagged to cut off the drive, he poured in midrange jumpers. Butler had no answer for the Notre Dame powerhouse.

Carr caught a few glimpses of Tony Hinkle's sideline demeanor during his rare moments on the bench. "Naturally he wasn't happy. He was kind

of demonstrative. He was letting his team know he wasn't happy with it, for sure. [But it] was such a fast-paced game he didn't really have a lot of time to do anything else except get ready for the next series."

Ultimately, the game was in the hands of the players, and the Fighting Irish simply had too much strength, depth and athleticism. Collis Jones scored forty points only to be overshadowed by his more well-known teammate. Carr scored fifty, which still stands as the record for a visiting player in the field house.

"They beat us 121–114," said Shepherd. "That's a high-scoring game back then for no shot clock and no 3-point play."

And so Tony Hinkle's basketball coaching career ended in a loss—a highly entertaining loss for the record crowd that strained the field house's capacity, but a loss nonetheless. The three-sport coach absorbed the outcome with his accustomed class and grace, but others were inconsolable.

"For me it was depressing because I wanted to win that game, Hinkle's last game," Shepherd said. "Knowing that he wasn't going to return as coach, that was a real disappointment, because that's why I chose Butler. He did not want to quit coaching. I didn't want him to, either."

Fresh off his performance in Hinkle Fieldhouse, Austin Carr led Notre Dame into the NCAA tournament field. If he was tired from his winning effort in Indianapolis, it sure didn't show. Carr set NCAA tournament records for most points in one game (sixty-one versus Ohio in a first-round win), most field goals in one game (twenty-five) and most field goals attempted in one game (forty-four). His individual scoring average of fifty points per game in seven NCAA playoff games is astonishing.

Bill Shepherd, who had played for Tony Hinkle in the post–World War II era, coached Carmel High—paced by Billy's sharp-shooting younger brother David—to the state title game in 1970. Billy and many Butler fans hoped Bill Shepherd Sr. might be the one to take the reins of the Butler program next. Instead, the university hired a younger Hinkle protégé.

"George Theofanis came in, and he had brought in three recruits from Shortridge where he had coached high school ball and it wasn't the same," Shepherd recalled. "It wasn't the same feeling and it wasn't the same atmosphere." Dave Shepherd, who had considered joining his brother at Butler, opted instead to attend Indiana.

Billy Shepherd stuck out his commitment to the Bulldogs. "We weren't as successful, so I think at the time you would reflect back and say, 'I wonder what it would be like if Hinkle were still coaching?'" Shepherd said in 2014.

The 1970 Mr. Basketball, Dave Shepherd, scored forty points in the 1970 state final, but Carmel fell to East Chicago Roosevelt. *Indiana High School Athletic Association.*

"The University was ill-prepared for his retirement," added Indianapolis newspaperman David Woods. "They didn't have much of a recruiting budget, and they couldn't appeal to his name and the respect players had for him anymore."

Butler made Tony Hinkle a special assistant to the president of the university and eventually gave him office space in the field house after an abortive attempt to place him elsewhere. Billy Shepherd remembered what it was like to have his mentor in the building as he worked out for a new coach.

"Even the next two years when I was playing there and he wasn't coaching, he'd still come in the building, walk around the top some during practice," Shepherd said. Then he paused, with memories audibly crowding his throat.

"I still can't walk into the place without thinking about him."

BIRD SITS, THEN FLIES

Larry Bird is rightfully nicknamed Larry Legend. His exploits at Indiana State and in the NBA made him a household name throughout the world.

Bird is also known by many as the "Hick from French Lick," probably the only reason most people have even heard of his tiny Indiana hometown. Bird was a good player in high school, when he starred for Springs Valley High School. Good enough to be named to the Indiana All-Stars. He no doubt dreamed of leading his teammates to a sweep of their rivals from Kentucky that summer.

The Indiana All-Stars got off to a good start, beating Kentucky 92–81 at Freedom Hall. Bird scored 12 points in that game and must have hoped for an even greater output in front of a home crowd in the second game. But head coach Kirby Overman kept Bird on a short leash in the rematch. The future twelve-time NBA All-Star scored just 6 points and seldom left the bench.

Indiana did earn the sweep. The second game was a high-scoring 110–95 win for the home team. But Bird was inconsolable afterward. With tears in his eyes, he vowed to prove his worth.

Who knows if that moment ran through his mind later, when Bird's Indiana State Sycamores played Butler during his sophomore season. But Bird was a starter in that game, and he finally got the chance to show what he was capable of in front of a Hinkle Fieldhouse crowd. Bird led the Sycamores to an 80–65 rout of the Bulldogs, scoring 47 points and pulling down nineteen rebounds.

It just goes to show you that you can't keep a good Bird down.

Larry Bird led the Indiana State Sycamores to a resounding 80–65 victory over the Bulldogs at Hinkle in 1977. His jersey is enshrined at the Indiana Basketball Hall of Fame. *Author's Photo.*

GERALD FORD

Even as many large events were shifted to Market Square Arena downtown, Hinkle Fieldhouse continued to draw prestigious visitors. On April 22, 1976, at 8:05 p.m., President Gerald R. Ford stepped up to a microphone in the field house to address a crowd gathered for a presidential speech, delivered as part of the Student Assembly Lecture Series.

His speech followed the tenor of prior presidential addresses in the field house, lauding the prosperity of the U.S. economy under his watch and laying a great deal of credit for the nation's fortunes at the feet of "the miracle man of the 20th century, the American farmer."

Following a relatively brief recap of his farm policies and a promise to work with Indianans to further strengthen the country's agricultural foundation, the president took questions from the audience. He responded to a professor's question about inflation, defended Secretary of State Henry Kissinger's role in his cabinet to another questioner and calmly reiterated his position on gun control. Each serious question that came his way was given a thoughtful response.

A transcript of the president's remarks from that evening revealed that one member of the audience pursued a more humorous line of inquiry:

> *Question: Mr. President, I am from Evansville Indiana.*
>
> *On several recent episodes of* Saturday Night Live, *you have been portrayed as being—(laughter)—shall we say, clumsy.*
>
> *Do you think that by portraying you this way, this has possibly increased your popularity among the average American?*
>
> *The President: Well, I have not quite thought of it that way. (Laughter) But if that is the end result, I am delighted to have that conclusion.*
>
> *Well, to be serious for a moment, I think in the world in which we live, you have to expect the bitter with the sweet and you have to take a little kidding here and there. You have to expect some sharp barbs in a political campaign, and you have to expect various people in the press and elsewhere to have a lot of fun with those things. You have to let it roll off your back like water off a duck's back, and that is what I did.*

The question might have seemed silly amid a forest of sincere policy inquiries, but it was not the first time that day that the subject had come up. At 1:00 p.m., over four hours before President Ford boarded the plane that would take him to Indiana, a single entry on his schedule sticks out among the national security meetings and high-level cabinet consultations. It read: "The President was telephoned by Chevy Chase, comedian and host of 'The Saturday Night Show[.]' The call was not completed."

The president might have dodged that potentially uncomfortable phone call and dealt smoothly with an impertinent question from the audience, but he couldn't avoid one final lukewarm appraisal before he left the field house. In a 2010 interview with *Sports Illustrated* writer Luke Winn, former Butler athletic director and football coach Bill Sylvester related another encounter:

When we walked to the spot where [Hickory] *High's fictional squad first entered the building, he pointed out the gate, but remembered it more as the location where President Gerald Ford was accosted, after a speech, by an old Butler equipment-room manager. "Mr. President," the manager said after stopping Ford by the drinking fountain, "I never voted for ya, but I love ya."*

No Place Like Hinkle Fieldhouse

Chicago-based news anchor Corey McPherrin, a member of Butler University's class of 1977, posted an online paean to the field house that beautifully summed up the importance of the building for students, even in years when the basketball team wasn't dominant:

Elkhart fans root on their team in 1971. *Indiana High School Athletic Association.*

THRILLS OF THE

1970

STATE TOURNAMENT

CHAMPIONSHIP TROPHY AND AWARDS

TRESTER AWARD

RUNNER-UP TROPHY AND AWARDS

The Roosevelt Riders celebrated in 1970 as the Shepherd family grimly accepted their runner-up trophy. *Indiana High School Athletic Association.*

Aside from my fraternity house, there's no place on campus where I spent more of my four years at Butler than Hinkle Fieldhouse.

As a radio-tv major and a budding sportscaster, I was involved in either broadcasting each basketball game or practicing on a tape recorder in the "crow's nest" high above the north basket. I remember so well how excited we were when a highly acclaimed kid named Larry Bird and the Indiana State Sycamores came to the Fieldhouse one cold winter night.

As a member of the swim team, I also remember the long hours we spent in the pool and weight room in the bowels of the Fieldhouse—a weight room that would look puny by today's standards in any junior high school in America. I remember the meets against our rivals Evansville, Wabash and Valpo in particular. Most of all, I remember the wonderful friendships I made and the great coach, Gene Lee, who made us all better swimmers and people.

If memory serves me correctly, the USA/Russia High School All-Star game I attended filled up the Fieldhouse, which was a rare sight in my era. The Fieldhouse would occasionally serve as a venue for rock-n-roll shows, and the one I recall best was Styx, which at the time was a hugely successful act and a surprisingly big time booking for our little school.

I also remember serving as a reporter for WAJC (Butler's radio station) at a rally for President Gerald Ford prior to the election in 1976. Afterward, I met the President and a picture of that handshake made the front page of the Indianapolis Star. *A copy of that picture can be found today at the Sigma Chi house (and on a wall in my basement!). I could go on and on.*

Suffice it to say Hinkle Fieldhouse meant a lot to me back in the day—and even more to me now. I love the way it smells. The way it looks. The way my spine tingles when I look up and see those rugged steel girders and the way the hardwood floor shines when the sun peeks through those classic windows high above. Whenever I walk in the door, I feel like I'm home again. And that is as good as it gets.

In 1972, the finals were moved to Indiana University's Assembly Hall and later to the RCA Dome and Conseco Fieldhouse. The building named after Tony Hinkle no longer saw as much high school action as it once had, but it was far from done with being a central attraction in the city.

SCORING RECORDS, THE COLD WAR AND *HOOSIERS*

In 1982, Hinkle Fieldhouse hosted an international event that had nothing to do with basketball or politics. The World Goalball Championships were contested on the field house floor that year. Head coach Jack Kearney led the U.S. men's team to a gold medal in the event.

The team sport of goalball was developed in 1946 specifically for blind athletes as a means of assisting the rehabilitation of visually impaired World War II veterans. Participants compete in teams of three and try to throw a ball that has bells embedded in it into the opponents' goal. Hinkle's magnificent raised floor provided an excellent platform for the international teams that came to Butler that year.

DARREN FITZGERALD AND THE LONG-DISTANCE SHOT

The legacy of Buckshot O'Brien demonstrated that undersized, tenacious local players could thrive at Butler. Enter Darrin Fitzgerald, a five-foot-nine point guard from George Washington High. When Fitzgerald arrived at Butler in 1983, the school's single-game scoring record, set by five-foot-ten Billy Shepherd against Arizona, stood at forty-nine points. Fitzgerald was a natural passer who could rack up the assists,

but he would eventually break Shepherd's record, with a little help from the NCAA.

Prior to the 1986–87 season, the only way to make three points on one play was to make a standard two-point shot, be fouled in the act of shooting, be awarded a free throw and sink that as well. The NCAA changed the game dramatically by adopting the three-point line. C.M. Newton, who was coaching Vanderbilt and serving as chairman of the NCAA Rules Committee at the time, later explained the impetus for the change.

"Our coaches were all doing the same thing. They were putting a big guy on the box and keeping him there and it became a wrestling match. As a consequence you had more sloughing, sagging-type defenses. The 3-point shot opened that up."

Still, when the rule changed, many hide-bound coaches, including Indiana legend Bobby Knight, scoffed at the wisdom of adding the three-point line. Rick Pitino, then head coach at Providence, embraced the change. He set Billy Donovan loose behind the new arc and took the small private school to a Final Four. Knight got the last laugh that season, winning a national championship with the help of Steve Alford's 107 three-pointers.

Team results were not quite as dramatic for the Butler Bulldogs, who struggled to a 12-16 record that same season, but the field house was abuzz with excitement, as Fitzgerald—a senior who had played his previous three years without the aid of the line—launched an individual assault on the NCAA record books, with the full backing of his coach and teammates, as described in *The Butler Way*:

> *Butler Coach Joe Sexson developed one drill in which three players rebounded for Fitzgerald and kept passing three balls to him. He'd catch and shoot, catch and shoot, catch and shoot.*
>
> *A season-ending injury to Chad Tucker, who became Butler's all-time scoring leader, left few options. Fitzgerald knew Sexson was serious when the coach benched and scolded him for passing to a teammate near the hoop. The ball went through the player's hands.*
>
> *"He told me if I ever passed up another shot, I'd be sitting the rest of my career at Butler," Fitzgerald said.*

As opponents began to crowd him at the arc, Fitzgerald simply stepped back again and continued to drill big shots.

Fitzgerald wasn't chucking the ball, either. He was shooting it with deadly accuracy. He splashed a stunning 43 percent of his deep attempts, on his

way to a 26.2-point-per-game average that season. In Midwestern Collegiate Conference (MCC) games, he was even more impressive, racking up a 31.3-point-per-game average against league opponents.

He scored 40 points and splashed ten 3-pointers in a loss to Loyola on January 10, 1987, but his masterpiece was yet to come. The Detroit Mercy Titans came to Hinkle Fieldhouse on February 9, no doubt well prepared for Fitzgerald's gunnery. Nothing they did that day could slow the mighty mite, who set school records that still stand today: he scored 54 points and hit twelve 3-pointers in an 88–77 Butler win in front of an ecstatic field house crowd.

"It doesn't matter how far out you pick him up, he'll score," said then Detroit coach Don Sicko after the game. "His range is just incredible."

Fitzgerald was the best 3-point shooter in the nation that season. He set long-standing NCAA records for 3-pointers made (158), attempted (362) and average made per game (5.6). He finished his Butler career with 2,019 points and was named to the school's all-century team.

Davidson's Stephen Curry broke Fitzgerald's record for total 3-pointers made in 2008, but nobody has come close to his 5.6-per-game average, which still tops the NCAA record books. His 54 points against Detroit is still the highest point total by a Butler player in Hinkle Fieldhouse, as well.

Darrin Fitzgerald may not be Butler's most famous former player, but his exploits still carry plenty of weight in Hinkle Fieldhouse and the sport of basketball.

STEVE ALFORD'S FIFTY-SEVEN

By the time Steve Alford and New Castle High rose to prominence in the early 1980s, it had been more than a decade since the state championship game had been a Hinkle fixture. The state finals were held at Market Square Arena in 1983, but Hinkle still hosted the semistate matchups. Alford, then a senior at New Castle, was well aware of the importance of the venue.

"Growing up as an elementary school kid and a middle school kid, I can remember going to semi-state there in Indianapolis," Alford said. "So I knew the history of that building, I knew how special it was, so the opportunity to play there was a big thrill."

New Castle players and fans may have felt the historical mystique of the place, but they were not intimidated by the size of the crowds. The Trojans' home gym, New Castle Fieldhouse, was and still is the largest high school

Basketball Coach George Theofanis

George Theofanis succeeded his former teacher and coach, Paul D. (Tony) Hinkle at the Butler helm last year. The 1970-71 campaign was his first collegiate campaign after 13 years in the high school coaching ranks. A native of New York, he received his B. S. degree from Butler in 1957 and his M. S. in 1964.

From 1957-63, he was head coach at Avon (Ind.) High School where he compiled a 70-50 record, then moved to Indianapolis Shortridge High School as assistant coach in 1963. In 1966, he became head coach and compiled the best record in the Blue Devils history over the next four years.

His four-year record includes an overall mark of 89-20, 3 Indianapolis sectional, 2 regional and one semi-state titles and he finished the final eight of the state high school tournament one other time. In 1968, he directed the Blue Devils to the final game of the state tournament. He also copped two city titles.

Theo was named coach-of-the-year in Marion County (Indianapolis) in 1966-67, runner-up for high school coach-of-the-year in Indiana in 1968, and Butler Alumni Coach-of-the-Year in 1967-68.

He served in the U. S. Air Force as Weather Service Instructor from 1952-56.

\#

George Theofanis was hired to succeed Tony Hinkle. This is his biographical entry from the basketball media guide from his second season, 1971–72. *Author's collection.*

gym in the United States. "We had already played in front of seven or eight sellouts at the field house my senior year," said Alford, speaking by phone from his office at UCLA , where he became head coach in 2013. "They'd put an extra set of bleachers up each time, so we played in front of about 10,000 fans. And when you play in the North Central conference, the smallest gym [seated] 6,500, and a lot of those games were sold out as well. So I'd played most of my senior year in front of really good crowds. So when we went to semistate into a place with the history of Hinkle, our team was used to the crowds, so that wasn't an issue."

New Castle fans also made sure to be there for the big game. The Trojans had drawn Broad Ripple as their opponents in their first semistate matchup. Broad Ripple's campus was just three miles away from Hinkle, and the Rockets no doubt had plenty of support in the building. Alford didn't feel like his fans were outnumbered at all.

"We were in the city of Indianapolis, but there were more New Castle fans there than Broad Ripple," he said. "At least, it seemed like it. We brought over twenty fan buses from New Castle that day, so we were extremely well represented."

Alford put on a show that nobody in the crowd that day would ever forget. He scored fifty-seven points, including twenty-five of twenty-five free throws, to propel New Castle past the hometown team. Alford's Trojans lost later that evening to Connersville, but Steve Alford's fifty-seven-point performance against Broad Ripple became legendary.

Hinkle Goes Hollywood

Every kid who grew up in Indiana was familiar with the story of Milan High. The tiny school's miracle run to the 1954 IHSAA title was bedrock lore in every corner of the state. "That was the story that the local paper would pull out every year," said Angelo Pizzo, who grew up in the hoops hotbed of Bloomington, Indiana.

The Milan Miracle would begin its journey from local legend to national cultural touchstone when Pizzo roomed with David Anspaugh at Indiana University in the late 1960s. "We both loved movies, and we talked about stories that would make great movies," Pizzo said. "We thought the Milan story would make a great movie."

Pizzo graduated from IU in 1971, went on to film school at USC and then built a solid career as a producer in Hollywood. A full decade later, the desire to make a film about basketball mania in his home state was still strong. After his alma mater won the 1981 national title over North Carolina, Pizzo began working in earnest on a script that would capture the heart and soul of his home. "I saw Indiana as a character in the movie, so it had to be accurate," Pizzo said, in Gayle L. Johnson's book *The Making of* Hoosiers. The only way he could ensure the authentic voice he wanted was to write it himself and have his friend Anspaugh direct. "He knew and understood these characters at a very deep level," Pizzo said.

There would be no stand-in geography, either. Pizzo and Anspaugh were committed to filming in Indiana, in real Hoosier gyms. "There was one incarnation of the project where the production company said because of the tax credits and favorable dollar exchange, they would only do it in Canada," Pizzo recalled. "We said 'It ain't happenin'.'"

Authenticity could only go so far, of course. This was still Hollywood. Pizzo's research turned up zero personal drama from the 1954 Milan team—they were a bunch of nice guys with a nice coach, which didn't make for much in the way of character development. So Pizzo created the fictional

Hickory High and wrote a coach in need of a second chance, some meddling townsfolk and a romantic subplot. Redemption would be the theme that gave emotional heft to the story of a plucky team from the middle of nowhere.

Finding old high school gyms to shoot in was not difficult. A handful of aging structures with basketball dyed in the wood of the bleachers were readily available. Best of all, the iconic building every Hoosier idolized was still standing and looking pretty much the same as it had in 1954—though the edifice then known as Butler Fieldhouse was now named after Tony Hinkle.

That change—heralded by the large block letters that spelled out HINKLE FIELDHOUSE across the row of monitor windows on the building's roof—did preclude any exterior shots of the building being used in the film. "It had changed enough that we couldn't get anything that would work," recalled cinematographer Fred Murphy. So the first shot of the field house that appears in the film is an interior, as the loading dock doors roll up and the Hickory Huskers enter the building. "[The shot] is copied from *The Right Stuff*," Murphy said. "There's a very similar shot where the astronauts are walking at you, and we decided to reference that shot. Also, the idea was to go from the narrow to the big: the next shot is a huge wide shot from way up in the stands, of them walking out onto the court, so you get an idea of how big the place is."

Murphy's camera magic lends a crucial perspective to one of the film's most famous scenes, as the Huskers gape in awe at the arched vastness of the arena. Gene Hackman, playing Coach Norman Dale, asks his players to measure the baskets as a way of pointing out that the court is the same size as the one in their one-hundred-seat gym at home, and the baskets are no higher than any they've shot at all year long. When a player shouts "Hickory!" on his way out the door, it echoes with confidence throughout the massive open space of the field house.

"To try to film an Indiana state championship anywhere else would have been a travesty," said Pizzo. "We didn't entertain the idea of shooting elsewhere. We shot the road to the state championship sequentially, so the last four days of the movie, we shot at the Fieldhouse."

The interior of the building required very little alteration to appear as it did in the 1950s. The filmmaking crew was also very happy with the quality of the light in the venerable structure. "The light was good enough and bright enough that I was able to shoot at high speed, around 96–100 frames per second for a lot of it," said Murphy. "Normal film speed is 24 frames per second. You can get guys running in slow motion and making shots. The basketball game looked terrific."

The building looked authentic, but some effort was required before the same could be said of the local extras who volunteered to serve as the frenetic fans. "All of the extras had to have '50s haircuts," Murphy remembered. "So we had 20 barbers under the bleachers cutting people's hair. They were all lined up there, and there was hair flying everywhere. It was amazing." Many of the extras brought their own vintage outfits.

The extras, who made the then minimum wage of $3.50 per hour, didn't come close to filling the arena's more than twelve thousand seats, so the filmmakers had to move them around between shots and keep some empty parts of the building darkened. To entertain the crowd and build some enthusiasm, they had Broad Ripple and Bishop Chatard play their regularly scheduled high school game at the field house during filming, as well. Maris Valainis, who played sharp-shooting Jimmy Chitwood, was a Bishop Chatard alum.

The film's conclusion—with Chitwood hitting the winning basket as time expired—could have seemed corny or clichéd if it had been shot anywhere else. In Hinkle, the emotion ran true. Valainis missed the majority of his warm-up shots while the crew was setting up the final basketball scene. Tension was mounting on the set, including among the crowd of nearly five thousand extras. Director Anspaugh's memory of that final scene is told in *The Making of* Hoosiers:

> "[Maris is] *already shaky in terms of his confidence. If I tell him to move closer, he'll think that I've seen him miss, then he'll think I don't believe in him."* Anspaugh's faith paid off. *"When we got the cameras rolling and the extras on their feet,"* he said, *"first take, boom, nothing but net."* Anspaugh described the eruptions of celebration on the court as *"pure, unbridled hysteria and joy"* because the fans had been hoping for Valainis to make the shot in real life. *"The reaction was so real,"* he said, adding *"That's part of the beauty of shooting a scene like that in Indiana."*

Cinematographer Murphy, who had never been in the field house before shooting *Hoosiers*, felt the location helped make the movie a success. "It provided that incredible ending, when one team is celebrating and the other team is downcast, and the fans are pouring out onto the floor," he said. "The emotional level of it was extraordinary."

For Anspaugh and Pizzo, the final days of filming reinforced their long-standing dream of making a film that captured the Hoosier Hysteria of their youth. Like thousands of basketball-playing Indianans before them, their

dreams had led them to the near-mythical environs of the field house, where their cameras couldn't help but capture the mystique they wanted to share with the rest of the world.

"It's so awe-inspiring," Pizzo said, nearly thirty years after shooting on the movie wrapped. "To this day I walk in there, and I'm still blown away by the place. It's a work of art. It's a thing of beauty."

KARCH KIRALY AND THE PAN AM GAMES

In 1987, international sports and politics had become inextricably linked. The United States had boycotted the 1980 Olympic Games, held in Moscow, to protest the then Soviet Union's invasion of Afghanistan. When the summer games were held in Los Angeles four years later, the USSR paid back the insult, though the official reason given for boycotting the trip to U.S. soil was "security concerns." Tension still lingered late in the decade as Seoul, South Korea, prepared to host the 1988 summer Olympics.

The 1987 Pan Am Games had been awarded to Santiago, Chile, but the South American delegation withdrew its bid early in 1984. The Pan American Sports Organization (PASO) awarded the bid to Quito, but the capital city of Ecuador—sitting a (literally) breathtaking 9,350 feet above sea level—backed out as well. In desperation, the sports organizing body awarded the games to Indianapolis, hoping that the city's existing sports infrastructure would be able to support the massive undertaking, even with a relatively short time to prepare.

Despite being PASO's third choice, Indianapolis embraced the challenge of hosting the Pan Am Games with customary gusto. Then vice president George H.W. Bush officially opened the games on August 7, 1987, in front of eighty thousand spectators who had packed the stands at Indianapolis Motor Speedway. Local luminaries Oscar Robertson and Wilma Rudolph lit the flame that burned throughout the duration of the games. Turnout was massive and enthusiastic, in part because Cuban athletes were appearing on U.S. soil. The communist nation, under Fidel Castro, had carried on a running political feud with the United States for decades, and those tensions filtered down to the athletes who marched under each nation's flag.

Basketball would take place at Market Square Arena, but Hinkle Fieldhouse landed the volleyball competition, which was also hotly anticipated. The U.S. team was led by Karch Kiraly, a three-time national champion from his

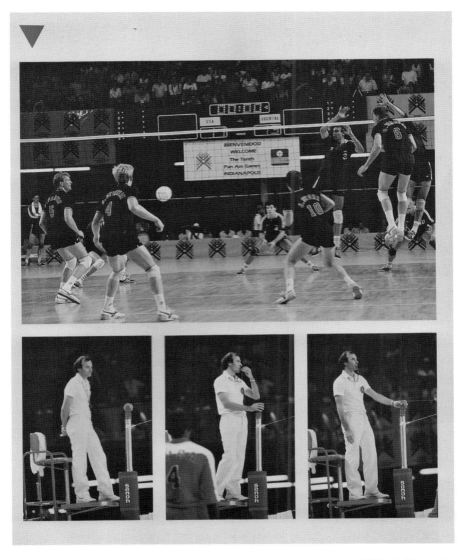

A page from a souvenir book commemorating the 1987 Pan Am Games. Volleyball legend Karch Kiraly praised local fans for filling the field house in sweltering conditions as they cheered Team USA on to a gold medal win over Cuba. *Author's collection.*

collegiate days at UCLA who had also led Team USA to a gold medal at the controversial 1984 Olympics.

Kiraly and his teammates were smarting from a visit to Havana two months earlier. The Yanks had lost to their hosts in a turgid five-set battle

royal, exacerbated by the presence of Cuba's controversial leader. "When Fidel Castro showed up at the finals, they were yelling under the net, pointing fingers and running around the court after they beat us," U.S. middle blocker Steve Timmons told reporters in Indianapolis. "We owe them something."

Speaking by phone from California twenty-seven years later, Kiraly still had an edge in his voice as he recalled the icy feelings that characterized the U.S.-Cuba sporting relationship. "They played with a lot of emotion and did a lot of screaming and yelling, so I can't say we were the closest of teams," he said. "Even regardless of the political situation, they were a really good team, and we were a really good team. We had a nice rivalry with them."

Kiraly's family background lent additional subtext to the clash of sports and ideology. "The two countries have radically different priorities. Liberty is very low on the Cuban list, and it's much higher on the American list. It's something I'm very aware of, since my father escaped from Hungary in 1956 during the revolution that started in late October, extended a few days into November and then was crushed when the Soviets sent in their tanks."

In purely athletic terms, the 1987 Pan Am Games were considered to be a crucial proving ground for national teams that would next appear in the Seoul Olympics. World-class teams from Argentina and Brazil were not about to hand the Pan Am gold to Cuba or the host country without a fight.

To make matters worse, Kiraly was nursing a broken hand that had kept him off the front row for five weeks. He played sparingly in the round-robin qualifying matches, one of which resulted in a U.S. loss at the hands of Brazil. The Americans came back to life as Kiraly's hand healed, beating the Cubans and their vocal superstar Joel Despaigne to finish preliminary play at 4-1. Both teams won through to the medal round, where Cuba, also 4-1, took on Brazil, and the United States battled Argentina. The archrivals won through, setting up a highly anticipated rubber match in Butler's steamy field house.

"I have very fond memories of Hinkle," Kiraly asserted. "Of course, there was no air conditioning, though. They just had fans blowing everywhere along the sides of the elevated floor to try to cool the court down. They were useless. It was boiling hot, really humid. But the crowds were so into it; it was a really memorable event."

Despite the tropical atmosphere inside the venerable building, a partisan crowd packed the field house on August 23. Curt Holbreich of the *Los Angeles Times* set the scene in a 1987 article:

For more than three hours Sunday, Karch Kiraly and Joel Despaigne battled across the net. It was a subplot to the United States vs. Cuba match for the gold medal in men's volleyball.

They yelled at their teammates, they screamed at each other, they rose [sic] the level of play to a crescendo that brought the estimated crowd of 15,000 at Hinkle Fieldhouse to its feet cheering almost every crucial point.

It seemed only fitting that the last point in the deciding fifth game, the one that would determine the 1987 Pan American Games champion, would come down to these two players.

The U.S. squad jumped out to an early lead, taking the first two games. Then the Cubans rallied to take the third and fourth games, forcing a fifth and final game with the gold medal on the line. Kiraly was playing under a yellow card, handed down by Canadian referee Claude Huot after a particularly nasty exchange between Kiraly and Despaigne. Kiraly had also been badly shaken when his friend Timmons—the giant with the distinctive red flat-top—ran afoul of one of Hinkle's more noteworthy features.

"He dove and made this amazing play, but he fell off the elevated floor and disappeared," Kiraly recalled years later. "I thought, the way he had fallen, that he was probably lying down there with a broken neck, so I felt horrendous. I hit the ball into the net because I was so concerned for my teammate. He still hadn't reappeared from below floor level."

Doctors later declared Timmons fit to finish out the match, but his temporary absence had left the American team in a must-win scenario. Fittingly, the final play pitted Despaigne against Kiraly, as the Cuban took a well-placed set from a teammate, sprang high off Hinkle's live floor and prepared to smash it onto the American side. Kiraly, lingering injury notwithstanding, leapt to meet his young rival, blocking the spike and sealing the title for the U.S. volleyball team in front of an ecstatic crowd. The final match, fraught with international tension and athletic rivalry, would remain a thrilling memory for participants and Indianapolis residents for decades to come.

9

RESURGENCE

B utler basketball wasn't exactly an afterthought throughout the 1970s and '80s, but the team did not make an appearance in the NCAA tournament in either decade. Fans of the team yearned for a return to the field house's glory days.

They would have to wait a little while for a return trip to the Big Dance, and Hinkle was no longer a major player in the high school basketball scene, but magic continued to happen as the final decade of the millennium played out.

BAILEY AND MONTROSS

One was a six-foot-three guard. The other was a seven-foot center. Quick, baby-faced Damon Bailey played for Bedford North Lawrence High School and had been recruited by Indiana coach Bobby Knight when he was in eighth grade. Hulking, glowering Eric Montross manned the post for Lawrence North in Indianapolis.

On the surface, the two young men had little in common, but they were linked by their shared status as superstars of high school basketball in Indiana in the late 1980s. Montross led the Lawrence North Wildcats to the state title in 1989, and Bailey's BNL Stars grabbed the trophy one year later in 1990.

Hinkle Auditorium is more than a sports venue for Butler University. Classes are taught in the building, and commencement ceremonies are held there. *Butler University.*

Montross left his home state to play for Dean Smith at North Carolina. It turned out to be a pretty good decision; the Tar Heels claimed an NCAA title over Michigan's "Fab Five" in 1993 with Montross's help. Early in that magical season, on December 20, 1992, the Tar Heels paid a visit to Indianapolis to take on Butler, so Montross got a chance to play in front of a hometown crowd. He did what he had always done in Hinkle. He won.

An Associated Press story told the tale:

> *Fifth-ranked North Carolina got 18 points from George Lynch and 13 from Eric Montross in whipping outmanned Butler in Indianapolis. During his prep days, Montross logged a 12-5 record in Hinkle Fieldhouse.*
>
> *"I loved being here again," said Montross, who led Lawrence North to the 1989 state championship. "I can't think of a better place to play. Hinkle has so many memories for me."*
>
> *It was a tough game for Barry Collier's boys, who were all 6-foot-8 or under, but Montross was magnanimous in defeat, saying "Butler's a good team. They're having some trouble shooting the ball." The fieldhouse again witnessed basketball history, as Dean Smith tied his mentor, Kansas' Phog Allen, on the all-time victories list, notching number 746. It was a rare*

moment when two other collegiate programs felt the glow of pride from an accomplishment made at Hinkle.

"It's kind of the crux of Hoosier basketball," Montross said of his return to Hinkle. "I just love the atmosphere there."

Unlike Montross, Bailey stayed home. He did exactly what everyone had expected of him since he was in middle school, signing to play for Bob Knight at Indiana. He would make his fateful return to the field house in a Hoosier uniform in 1993 and accept an assistant coaching position with Butler's women's basketball team in 2013.

DRIVING HOME

Tony Hinkle had been forced to retire in 1970, but he remained a constant fixture inside the building that bore his name. He shared an office in the field house with Bill Sylvester, his successor as the head of Butler's athletic program, and was photographed consulting with Barry Collier in the late 1980s as the field house was set to undergo one of its early renovations.

It was around this time that the legendary coach turned ninety years old. He was still motoring around Indianapolis in his 1978 Cadillac, and he wasn't above a bit of trickery to keep his driving privileges intact. Howard Caldwell related a classic story in *Coach for All Seasons*:

> *In 1989, when he was approaching his ninety-first birthday, he worried about his ability to pass a driver's test and decided to go on the offense. He initiated a visit to an automobile license branch well ahead of the deadline. The branch was near where he lived. He suggested to the examiner that when it came time for him to drive, the examiner might be interested in getting a look at the newly renovated fieldhouse and he would be glad to drive him out there. It was precisely the route Hinkle took six days out of seven. He could almost drive it with his eyes closed. Hinkle passed.*

Hinkle's concerns about his driving were well founded. Bob Deitz, who had been a loyal assistant under Hinkle, had become an insurance agent and made sure to keep his friend's auto insurance in order. One day, he told Hinkle's family that he was afraid Tony's driving would result in an accident and a possible judgment against the living legend.

Bob Dietz was Tony Hinkle's loyal assistant for decades. Frank "Pop" Hedden coached the freshman team and briefly took over the varsity while Hinkle served in the navy during World War II. *Author's collection.*

That outcome was only narrowly avoided one day, when Hinkle left his lights on in the field house parking lot and had someone else recharge his battery for him. Hinkle always left his vehicle in park, but the good Samaritan had left it in neutral after topping up the battery. The former coach came out to his car, started it and flipped the transmission lever one notch back, as was his habit. Instead of reverse, the Caddy ended up in drive, and Tony was off to the races, barreling toward the Starlight Musicals stage at speed.

The car clipped a cable attached to the stage but managed to not do any further damage before it came to a stop. Hinkle was unhurt, and so was everyone else on campus, more through the grace of good luck than any driving skill on the nonagenarian's part.

In 1990, when the Indiana Basketball Hall of Fame opened in New Castle, Hinkle wisely accepted a ride from his former player Bob Nipper. The two enjoyed the ceremony immensely, and Tony got a priceless opportunity to chat with Oscar Robertson.

Tony Hinkle passed away in 1992. Mourners packed the field house to pay tribute to the great man whose loyalty, integrity, commitment and tenacity seemed to inhabit the very bricks of the building. A silver-white casket rested in the key at the north end, surrounded by blue and white flowers. University president Geoffrey Bannister gave a stirring eulogy.

"He was from and of an Indiana that we long to see again," Bannister said. "He was a bridge to our own better times and better values. Because of this, his very presence was a constant physical reminder of who we should be."

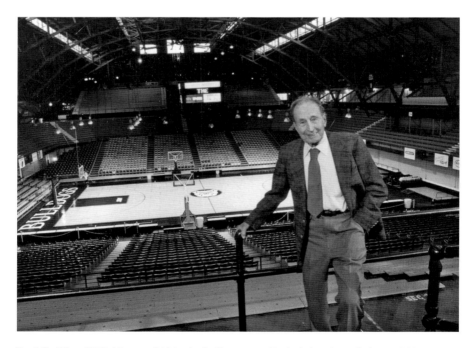

Paul D. "Tony" Hinkle won 560 basketball games as Butler's head coach from 1926 to 1970. Butler Fieldhouse was named in his honor in 1966. *Butler University.*

Bannister referred to the field house as "Tony's cathedral, his home and his sanctuary. Tony Hinkle showed what can be done when love of place is allowed to triumph over love of self."

Friends and fans said their goodbyes, and then Tony Hinkle's body left the building for the final time. He was buried at Crown Hill Cemetery alongside a president, a poet, several Civil War generals and the founder of his beloved university, Ovid Butler.

The man who built the "Hinkle mystique" was gone, but his spirit would infuse the building forever after.

REVIVING THE BUTLER WAY

"I wasn't born in Indiana, but I got here as fast as I could."

That's how Barry Collier characterizes his late-blooming love for the state of Indiana. Collier grew up in Florida and spent two years at Miami Dade Community College. When it came time to choose a place to finish out his college career, he was willing to look far and wide. Fortunately for all concerned, he made an on-campus visit to Butler University.

"Well, I had my *Hoosiers* moment," Collier said years later, "when they walked in and their jaws dropped. Mine came during my recruiting visit in March of '74. I chose Butler for other reasons, too, but Hinkle was one of those reasons."

Collier played for two years under George Theofanis. As a senior, he averaged 15.2 points and a team high of 7.5 rebounds, and he earned the first team all-conference recognition in the Indiana Collegiate Conference. He collected his bachelor of science degree at Butler and earned his master's degree one year later from Indiana State. His collegiate assistant coaching career took him to the West Coast, from Seattle to Idaho to Oregon and eventually to Stanford.

In 1989, Collier, who was actively seeking a head coaching position, saw that his alma mater had an open job. Not content to simply apply, Collier sent Butler president Geoffrey Bannister a forty-five-page document detailing his vision for resurrecting the basketball program.

"The guy who followed George Theofanis was Joe Sexson, the best high school athlete in the history of Indiana, bar none," Collier said. "He played football, baseball, basketball…was a great athlete. So I followed him in '89, and part of the vision from Butler's president at the time was to use basketball

Barry Collier has been a player, coach and athletic director for Butler University. He has ensured that the field house has retained its essential character throughout the years. *Author's photo.*

to elevate Butler University. So first you have to have a successful team and part of that is facilities. So we developed a plan to make some renovations, and they were pretty significant."

The plan added some bench seating to Hinkle Fieldhouse and made the entrances near the parking lot more visually appealing. The field house parking lot was paved, and new locker rooms and offices for football, basketball and volleyball coaches were installed along the concourses.

One change in particular drew the attention of Tony Hinkle, who still had an office in the field house at that time. "They put in a hospitality space—a big room that had a bar at one end. But there was carpet, new lighting, wallpaper. It was a nice room," Collier recalled. "[Hinkle] went home and told one of his daughters, 'You won't believe what they did to the fieldhouse.' And his daughter says, 'What? Did they knock it down?' and he said, 'They put a saloon in the fieldhouse.' That was his idea of what that room was."

With the field house improved, Collier set about restoring the Bulldog basketball team to its former glory. It wasn't easy. His first team finished 6-22, and Collier felt he had performed badly enough to be fired. Indeed, he was summoned to meet with the university leadership in 1990, but his

Joe Sexson led the Bulldogs from 1977 to 1989, amassing a .432 winning percentage over twelve years at Butler. His star player in 1982–83 was No. 50 Lynn Mitchem. *Author's collection.*

prediction turned out to be wrong. He was, instead, offered a four-year contract extension.

With Darin Archbold's help, Collier's next team went 18-11 and made it to the National Invitation Tournament (NIT) in 1991.

The field house magic came alive in a timely fashion when Indiana visited in November 1993. The Bulldogs had averaged an anemic attendance of 3,970 for conference games in 1992, but a visit from the powerful Hoosiers filled the bleachers (albeit with boisterous fans in red and white). In front of a raucous crowd, the Bulldogs sent the visitors—led by Damon Bailey—back to Bloomington with a 75–71 loss.

Bailey scored twenty-three points in his return to Hinkle, and hall of fame coach Bob Knight paid the Bulldogs a potent compliment. "Butler came right out and played better than we did, played harder than we did. They just carried that throughout the entire ballgame," the legendary coach said after the game. "They played excellently defensively."

Still, the dream of returning to the NCAA tournament eluded Collier and the Bulldogs. Then, in 1995, Butler's head coach had an opportunity to pump Wisconsin coach Dick Bennett for information. Bennett's defensively oriented approach clicked with Collier, and Butler's fortunes began to improve.

Butler won the league's automatic bid in 1997. Saddled with a fourteen seed, the Bulldogs promptly lost to Bob Huggins's Cincinnati Bearcats. The next season, Butler improved slightly to a thirteen seed, but the outcome was similar. The New Mexico Lobos sent them home. In 1999, Butler missed the tourney, but 2000 was a watershed year for the program's national image.

The country as a whole had started to take more notice of "Cinderella" teams from schools with small enrollments in middling conferences, teams that "shouldn't win." Butler was primed to play David to Florida's Goliath in the first round in 2000. In a tense first-round game in Winston-Salem, North Carolina, the twelfth-seeded Bulldogs gave the Gators all they could handle.

Billy Donovan's Florida squad was loaded, but the Butler Way was in full effect. The Bulldogs led 56–49 with 4:18 to play in regulation, and they felt good about the game's slow tempo. If they could hold on, Butler would gain its first tournament win in thirty-eight years.

Future pros Mike Miller and Udonis Haslem made the most of each field goal and free throw they earned in the remaining time, forging a tie to end regulation. In overtime, Butler held a three-point lead on two separate occasions but could not add to it.

Eventually, Florida's aggressive, pressing defense began to stymie the Bulldogs. The bigger, more athletic Gators grabbed key rebounds. Junior

LaVall Jordan missed two key free throws with his team up one in the closing seconds of the overtime period, and Miller rolled a layup in just as time expired. Butler had come so close, but the game was a narrow 69–68 win for the SEC school.

After that season, Barry Collier was tapped to be the next head coach at Nebraska. He would return to his alma mater in a different role in later years, but his stint as head coach had been an undeniable success. He had revived the Butler Way and showed the Bulldogs how to win on a national stage. The program was just beginning to test how high it could fly.

In 1991, Hinkle Fieldhouse nearly lost the right to host the boys' high school sectional. Renting out the building cost $1,617 per session, and the IHSAA was not keen on picking up that tab, regardless of historical context. In 1993, the sectional did move to Lawrence North, and associate commissioner Ray Craft—a star on Milan's 1954 title team who played for Tony Hinkle at Butler—told local reporters that the executive committee had nearly moved the semistate out of the old barn as well.

"They started going to the high schools because they could get free police, free everything," Barry Collier said. "High school gyms would seat around 8,000 people."

In 1998, high school basketball changed again, as the IHSAA elected to impose a class system over high school basketball in the state. With the basketball landscape fracturing into smaller chunks, Hinkle's time as a host site for tournament games seemed to be coming to an end. The decision didn't sit well with many Indianans.

"So much of the tradition of our tournament revolves around this facility," said Ben Davis head coach Steve Witty. "This place, in my opinion, is a state treasure."

Star writer Mike Beas wrote what many were thinking: "You've taken away our one-class tournament. At least let fans, media members and players have one Saturday each March to enjoy Hinkle Fieldhouse, a facility that gets older without getting old."

MID-MAJOR POWERHOUSE

Thad Matta was the next man hired to run the Butler program. Matta had played at Butler from 1987 to 1990, and his former head coach Barry Collier had hired him as a Butler assistant coach in 1997. When Collier left for Nebraska, the fiery Matta was the clear choice to succeed him.

Matta led the Bulldogs to a 23-7 season, another Horizon League crown and a return date in the NCAA tournament. His Butler team delivered on the promise shown by the 2000 squad, earning a number ten seed and beating Wake Forest in the round of sixty-four. Two days later, they lost badly to eventual national runner-up Arizona, but notice had been served. Butler was dangerous and would remain so.

Matta coached only that one season at Butler. He decamped for old rival Xavier at the end of the 2001 season and spent three seasons there before moving up to Ohio State. Matta's replacement at Butler, Todd Lickliter, was nearly his polar opposite in temperament. But even-keeled "Coach Lick" would push his team to even greater heights.

ARCHEY'S STREAK

Hinkle Fieldhouse is home to a few basketball records. One that stands atop the NCAA ledger belongs to Darnell Archey. The Butler guard sank an

Thad Matta, a former Butler player and assistant coach, took the reins for one season before moving on to Xavier and then Ohio State. *Author's photo.*

incredible eighty-five consecutive free throws without missing over a nearly three-year period.

Archey's streak started in Hinkle on February 15, 2001, against league foe Wisconsin-Milwaukee and ended January 18, 2003, against Youngstown State, also on Butler's home court. One might have forgiven scorekeepers for adding points to the Bulldog total before Archey even toed the charity stripe during that time.

The previous record had been set at seventy-nine by Villanova's Gary Buchanan. Buchanan's streak snapped in 2001, right around the time Archey's began.

There were some memorable moments along the way. On December 29, 2001, just before a new year began, Butler was ranked number twenty-three in the nation. Indiana, unranked at the time, played the Bulldogs at Conseco Fieldhouse as part of the modern Hoosier Classic. Butler trailed by as many as nine points in the second half but had drawn even with 2:10 remaining. Hoosiers coach Mike Davis was whistled for a technical, and first-year Butler headman Todd Lickliter sent Cool Hand Archey to the line.

Archey sank both, giving Butler a 62–60 lead. Two minutes later, Joel Cornette dunked a Thomas Jackson miss as time was running out, giving

Butler a 66–64 victory over the Hoosiers. Indiana had won thirty-nine straight games in the classic by that point, a team streak that fell victim, in part, to Darnell Archey's individual streak of consistent accuracy.

In a 2012 article on yahoo.com, college basketball writer Jeff Eisenberg asked Archey if he thought the record would ever fall. Archey was characteristically humble. "As they always say, records are meant to be broken," said Archey. "It may take awhile, but I think somebody will get it. With all the shooting devices and the amount of time these guys spend shooting, it's going to be broken eventually."

Archey served as an assistant coach at his alma mater for several years. When former Butler star Matthew Graves was made head coach at the University of South Alabama in 2013, Archey was his first hire. The Jaguars were a middle-of-the-road free throw shooting team in that first season, but senior forward Augustine Rubit went a perfect ten for ten from the stripe against Gonzaga in one game.

Hitting more than eighty-five free throws in a row might seem like a tough record to break in the era of highlight-reel dunks. But given time, would it even be a surprise if Darnell Archey coached a player who was up to the task?

SWEET SIXTEEN

Butler's 2002–03 season started out very hot with the team winning ten straight games. The Bulldogs lost at Hawaii to end that streak and then ripped off five more wins. Todd Lickliter's Bulldogs played with poise, eking out a 81–74 overtime win at home over Loyola in January and bouncing back after a 80–60 "learning experience" against number five–ranked Duke. In late February, in a tight conference race, the team fought tooth and nail for a double-overtime win at Cleveland State. It seemed like they'd been through everything and come out stronger.

Still, an early loss at Milwaukee rankled. Butler's final home game of the season—Senior Night—would be a rematch with Milwaukee at Hinkle. With both teams hoping to capture a regular-season crown, the game took on added significance.

With hostilities in Iraq casting a pall over the festivities, some questioned whether so much importance should be placed on a game. Butler senior Brandon Miller touched on the fact that everyday American victories are worth celebrating, even in times of war.

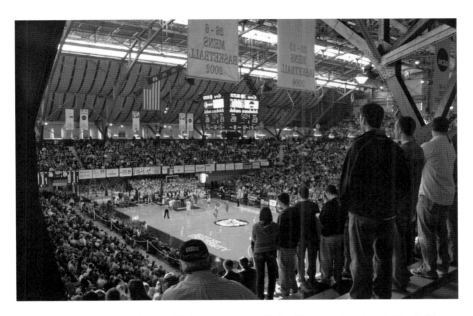

Hinkle's rafters began to fill up with banners as the Butler Way produced enviable dividends in the early 2000s. *Author's photo.*

"I'd like for people who say that [it's only a game] to experience Senior Night," Miller said after the game. "I'd like for them to give each of their teammates a hug, and I'd like for them to see those teammates bawling in tears because this is the last time we'll play together on this floor. I'd like for them to experience Hinkle, and I'd like for them to watch how both these teams fought."

"When you have passion for something, it's always more than a game," added Lickliter.

The contest itself was a game of runs. At one point, Butler was up by 16 and seemed ready to cruise to victory. But Milwaukee head coach Bruce Pearl exhorted his players to fight on, and the lead evaporated. The visiting Panthers held a 74–73 lead with less than a full second left in regulation. With barely enough time to get the ball inbounds and up the court, Butler needed every bit of the Hinkle magic.

The ball came to freshman Avery Sheets, who shot a three-pointer on the run. The improbable shot went in, and chaos reigned. Butler fans leapt up into the air, Milwaukee fans dropped to the floor in agony. The league title, and the top seed in the Horizon League tournament, was going to Butler. Milwaukee won the league's postseason tournament, earning a twelve seed

in the West region of the NCAA tournament. Butler was granted a rare at-large bid on the strength of a 25-5 record.

Butler was awarded the twelve seed in the East Regional. In the team's first game against Mississippi State, defense ruled the day. The Bulldogs from Indianapolis crept to a 47–46 edging of the Bulldogs from Starkville, Mississippi. In their second game in Birmingham, Butler had to pick up the pace. Number four–seeded Louisville also fell, but this time, the score was a more lively 79–71.

In the second week of March Madness, Butler was slated to face Oklahoma, the top seed in its bracket. The Sooners were led by Big 12 Player of the Year Hollis Price, who was nursing a sore groin, and Ebi Ere, who was struggling to recover from a broken wrist suffered earlier in the season. Even so, the Sooners were too much for the Bulldogs. Ere scored 25 points to shake off the rust, and Oklahoma hounded Butler's feared three-point shooters on the perimeter. The final score was 65–54.

Butler had made a statement, advancing to the Sweet Sixteen for the first time in the modern era. Tony Hinkle had only needed one win to make the round of sixteen in 1962, when the NCAA tournament field was restricted to thirty-two teams. The team's resiliency and consistency seemed to flow naturally from head coach Todd Lickliter's quiet authority.

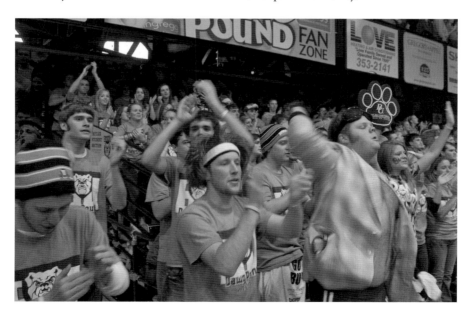

Butler students watched their team become a national powerhouse again from prime courtside seats. *Author's photo.*

Brandon Crone witnessed Butler's Sweet Sixteen run while he was still a standout senior at Frankfort High. At the time, he was being recruited to Butler by Todd Lickliter. Crone recalled how Lickliter's approach to life and coaching carried over to his team.

"No ego with him. There was no 'coach's way only,'" Crone said in 2014. "He'd listen to players and was open to making changes to help you. He wasn't a loud screamer; he wasn't always cursing at you. His overall demeanor was something I relished. He held you to a high standard of accountability all the time without having to yell."

A Made-for-TV Event

On December 10, 2004, ESPN sent cameras, lights and announcers to Hinkle Fieldhouse for a high school game. It had been decades since prep hoops had taken center stage on Butler's campus, and this was to be an entirely different event. Two of the nation's top high school teams, Indiana's Lawrence North and Poplar Bluff High School from Missouri, would face off for a national television audience.

Two players, in particular, had captured the eyes of college scouts. Greg Oden, a seven-foot junior center, was the highly touted leader of Lawrence North's team. Six-foot-nine Tyler Hansbrough, who had already committed to North Carolina, was the centerpiece for Poplar Bluff. Jeff Rabjohns of the *Indianapolis Star* described the action:

> *After the first half of Thursday night's nationally televised game, Lawrence North junior Greg Oden didn't look like the top player in the nation. One basket. Two points. His team trailing by three points.*
>
> *Three minutes into the second half, everything changed.*
>
> *Oden threw down one powerful dunk after another, starting a highlight show that lasted until Lawrence North's 56–40 victory over Poplar Bluff (Mo.) was finished.*
>
> *When it was over, the 7-foot junior had 16 points on 7-of-9 shooting, with five dunks, five rebounds and two blocked shots.*
>
> *The televised spectacle was played in front of approximately 7,000 at the fieldhouse, giving the nation a good look at the historical landmark. Hansbrough scored 16 points, shooting 7-of-14 from the floor, with 12 rebounds, one assist and one block.*

Oden was named Indiana's Mr. Basketball as a senior. He and his Lawrence North teammate Mike Conley Jr. would commit to Ohio State and make a run to the 2007 championship game under former Butler head coach Thad Matta. Hansbrough led the Tar Heels to a 2009 NCAA championship. He returned to Indianapolis after being drafted thirteenth by the Indiana Pacers.

150 YEARS, TWO PRESIDENTS

In November 2005, former U.S. president Bill Clinton spoke at Hinkle Fieldhouse as part of Butler University's 150th anniversary celebration. The *Indianapolis Star* reported on the grand event:

> *With the tune of "Back Home Again" playing over the speakers, the diverse crowd cheered and offered a standing ovation as Clinton, escorted by U.S. Rep. Julia Carson, D-Ind., took the stage. "You keep that up, you'll lose your reputation as a red state," Clinton said, referring to Indiana's strong Republican leanings.*
>
> *Clinton is the fifth American president to speak at Butler, but he noted he is "the first Democrat, and I want to thank you."*

The former president centered his remarks on America's role as a world power. "There's very little we can do alone," he said. "I don't care how powerful you are." He pointed to terror, corrupt foreign governments, poverty and climate change as the greatest issues facing the nation. He added that increasing trade and economic aid might help unstable countries reject religious fanaticism that sprouts terrorists.

On March 2006, another former president, George H.W. Bush, visited Hinkle Fieldhouse to celebrate the sesquicentennial.

"Instead of sitting on the sideline complaining," he told a field house crowd estimated at roughly nine thousand, "roll up your sleeves and get involved."

Bush spoke about volunteerism and his bipartisan work with Bill Clinton to raise money for disaster victims. The two subjects were paramount in the national consciousness at the time, as the government, headed by Bush's son George W. Bush, dealt with criticism related to the federal response to Hurricane Katrina, which had devastated New Orleans in 2005.

From 1928 to today, the field house has stood for more than just great basketball. *Author's photo.*

The elder president Bush had teamed up with his former political foe Bill Clinton to raise money for those affected. "There isn't a problem we have in America that caring citizens aren't trying to solve someplace in the country," Bush said. "I do think that the country wants more cooperation from people of opposing views and opposing parties."

Many who attended the speech appreciated the former president's appeal to bipartisanship. The *Star* quoted retired Butler professor Herb Schwomeyer, eighty-seven, who had seen Presidents Kennedy, Johnson, Ford, Eisenhower and Clinton speak at the university. "I'm a student of history," Schwomeyer said, "and anytime you have the chance to hear a president, whether he's Democrat or Republican, you ought to go."

Bush finished his speech with another appeal for individual involvement. "There is no definition of a successful life that does not involve public service," he said. "If I could leave just one message for Butler students, it would be to encourage you to get involved in public service."

Sweet Sixteen Redux

Despite the popularity of the film *Hoosiers*, Hinkle Fieldhouse was still a bit of an enigma outside Indiana. Even as the team became a national fixture, Butler games were still rarely televised outside the local area. Brandon Crone, who played at Butler from 2003 to 2007, felt like that started to change during his tenure at the school.

"My junior year, '05–'06, people started to say, 'Oh, you play in Hinkle!' It got more notoriety. Really, though, my senior year, which was '06–'07, when we won the preseason NIT tournament, they really talked about Butler and Hinkle, and from that point on, you really got the national attention."

Butler was respected at the beginning of that 2006–07 season, but few expected it to be good enough to thrive in the blockbuster field assembled for the preseason NIT. North Carolina was the favorite, but the Tar Heels expected some stiff competition from the likes of Baylor, Gonzaga, Indiana and Tennessee.

Butler began play at Conseco Fieldhouse, edging Notre Dame 71–69. The next day, the Bulldogs beat another old regional rival, Indiana, by 5. One week later, at Madison Square Garden, they proved their first two wins had not been a fluke, beating Tennessee to make the final. On the other side of the bracket, Gonzaga had made good as well, dispatching North Carolina to set up a mid-major-flavored title game.

A.J. Graves scored twenty-six points to lead Butler in the final, and his team built an eighteen-point lead. Bizarrely, the Bulldogs from Indianapolis failed to score a single field goal over the final eight minutes but held on to enough cushion to beat the Bulldogs of Spokane by eight.

But there would be no rest for the weary. Butler had to execute a quick turnaround for its next home game, having fallen victim to its own unexpected success.

"I don't think our coaches or a lot of people at the time gave us a lot of hope to beat Notre Dame and Indiana and go to New York," Crone recalled in 2014. "So they had scheduled a game with Kent State, and we ended up only having a one-day rest, and that game went into overtime. The place was rockin' and we had just won the NIT, so there were a ton of fans. Then we went into double overtime and ended up pulling out the win. That was a fun game."

As the team that played in Hinkle built up a sterling record and a national profile, the building began to fill with fans who wanted to experience the Bulldogs' resurgence. The field house was packed for a February 17 loss

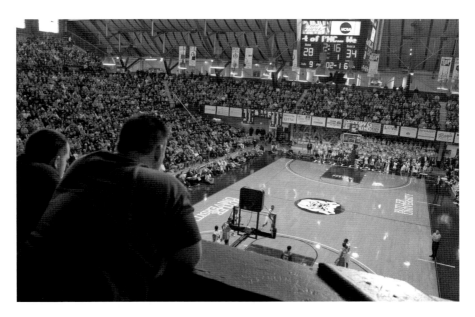

Despite several renovations over the years, Hinkle has never lost its quirky charm. This small overhanging section of seating on the building's north side is just one example. *Author's photo.*

to number sixteen–ranked Southern Illinois, and Crone and his teammates rewarded fans with a 13-3 league record.

One tough home loss came on Senior Night, with a pair of local luminaries in attendance. The *Star* reported on a bit of tough love that was dished out after the bitter loss to Loyola:

> [Tony] *Dungy, the Colts coach, addressed Butler's team late Thursday night after the Bulldogs lost to Loyola 75–71. Earlier, he and Colts president Bill Polian stood at center court during halftime with the Lombardi Trophy.*
>
> *Dungy reminded the Bulldogs, who have lost three of their past five games, that the Colts also floundered late in their season. The Bulldogs' run to the championship in November's NIT Season Tip-off inspired the Colts, he told them.*

"It was great to hear that," Crone said. "When you look back and see the run we had, to have him come in and say, 'Guys, you're all right' was good."

Butler earned an at-large bid for the second time under Lickliter and said farewell to the land of the double-digit seed. As a number five seed in

the Midwest bracket, the Bulldogs were expected to beat their first-round foe, Old Dominion, and they did. After that came a mild upset over Gary Williams's fourth-seeded Maryland Terrapins. Butler bowed out to Florida in the Sweet Sixteen, but the epically loaded Gators went on to win their second straight national championship days later.

Todd Lickliter was named NABC Coach of the Year after that season, and he would accept a head coaching job at Iowa shortly thereafter. Even as another successful head coach departed, a deeper sense of destiny came over the Butler program. The basketball team operated on a set of principles that provided a throughway as coaches and players came and went from the program. A Butler Bulldog was no longer an underdog.

"We had some bad eggs my freshman year, a couple of guys who just didn't want to buy into the Butler Way that we talk about now," Crone said. "That was really special to feel like we got it headed the right way and were able to show the new recruits coming in how to build it. They bought into what we were selling and what we wanted to accomplish."

Crone is now an assistant coach at Nova Southeastern, where he imparts some of the lessons he learned from Lickliter. The Indiana native still loves to visit the field house when he has a chance to come home.

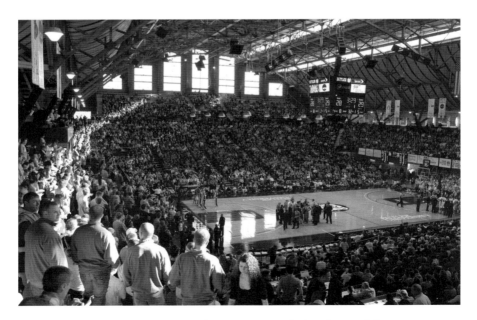

The magical light through Hinkle Fieldhouse's eastern windows is one of the more memorable experiences a college basketball fan can have. *Author's photo.*

"The best thing I can say about Hinkle is what a family-oriented place it is," Crone said. "Everything's so approachable. It's one of the few big-time college places where they still let the kids go out and shoot at the hoops after the games. That's pretty special."

The urge to return home to Hinkle runs deep in players and coaches from Indiana. On December 1, 2007, Thad Matta brought his Ohio State team, fresh off a run to the national final, into the old barn for a nonconference game. He went home with a 65–46 loss, proving that sometimes, you just can't go home again—at least not if you want to win.

SPRINGBOARD TO THE FINAL FOUR

B arry Collier's vision had revived the sense of pride in the Butler Way. He and his successor as head coach, Todd Lickliter, had brought the program to a point where the team was expected to make the NCAA tournament and win once it got there. When Collier returned to Butler to serve as athletic director in 2006, he had no intention of resting on those laurels.

THE RISE OF BRAD STEVENS

When Todd Lickliter departed for the Big Ten, his replacement was Brad Stevens. Stevens was the second-youngest head coach in Division I basketball when he was hired and nearly a complete unknown outside of Butler. His slight physique and youthful features tempted some outsiders to question if he was old enough to drive. Stevens, who had played college basketball for DePauw University, made no verbal reply. He let his coaching speak for him.

In his first season as Butler's headman, Stevens led his team to a stunning 30-4 record. Bob Knight's Texas Tech squad was one early victim. "I wish we played half as smart as they do," the Hoosier legend said after the game. Stevens and the Bulldogs also victimized Michigan, Ohio State and Florida State in nonconference play. They lost only two Horizon League games and cruised into the 2008 NCAA tournament, where they beat South Alabama easily and took Tennessee to overtime before bowing out.

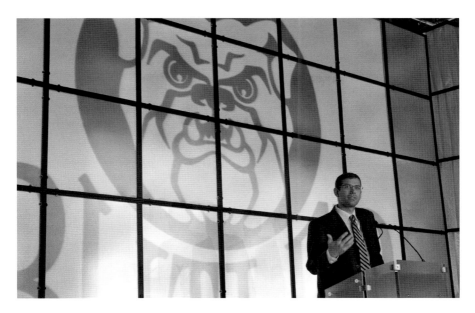

Head coach Brad Stevens led the Butler Bulldogs to back-to-back appearances in the NCAA title game. *Michael Kaltenmark/Butler Blue II.*

Stevens's second Butler squad lost four starters from the previous season and was picked to finish fifth in the Horizon League. Instead, the Bulldogs started 26-5. Midway through the season, Stevens picked up his 50th win as a head coach. He had lost only 6 games along the way. Stevens was named Horizon League Coach of the Year, and his team was awarded an at-large berth to the 2009 NCAA tournament. A first-round loss to LSU ended the postseason much sooner than Butler fans had hoped.

The 2009–10 season felt different from the very beginning. The season opened with an afternoon game—the type Hinkle's east-facing windows were made for—against Davidson. Butler, ranked eleventh in the nation, dispatched the Wildcats 73–62 and began one of the most difficult nonconference slates they had faced since Tony Hinkle's day.

A tough schedule gave the Bulldogs plenty of chances to test themselves. They won at Northwestern and Evansville. A trip to the 76 Classic in Anaheim yielded a loss to number-twenty-two team Minnesota, a win over UCLA and a one-point loss to Clemson, ranked nineteenth.

The Bulldogs had dropped to number twenty-two before they suffered another loss to Georgetown in the Jimmy V Classic. A return to Hinkle Fieldhouse revived Butler; the squad, paced by athletic forward Gordon

Students line up in the cold to get good seats during Butler's regular-season run to the NCAA tournament in 2010. *Author's photo.*

Hayward, defeated Thad Matta's number-thirteen Ohio State Buckeyes and edged a tough Xavier team one week later.

Brad Stevens's team suffered just one more hiccup—a ten-point loss at Alabama-Birmingham—before embarking on an absolute destruction of the Horizon League. On December 31, Green Bay fell in the field house. After that, the Bulldogs wouldn't lose another game for three months. An unblemished 18-0 run through the conference, topped by two league tourney victories, sent Butler into the NCAA tournament's West bracket with a number five seed. They were riding a 20-win streak and planned to extend it.

The Final Four would take place in Indianapolis in 2010, and that fact was not lost on the Bulldogs. Brad Stevens had put his team through a brutal nonconference season in hopes of building a roster that was mentally prepared for a postseason run. Four wins would put his team in a position to challenge for a title in its hometown.

Twelfth-seeded University of Texas–El Paso jumped out to a 33–27 lead over Butler in the first half of a March 18 first-round game in San Jose. In the second half, Shelvin Mack's quick hands and deep-shooting touch took over. Mack tied his career high, scoring 25 points. Hayward kicked in 13, and six-foot-eight warhorse Matt Howard had 11 as the Bulldogs advanced to the second round.

The thirteenth-seeded Murray State Racers had dispatched a bigger, stronger Vanderbilt team to reach the second round, and they nearly put paid to Butler's dream season as well. Gordon Hayward's instinctive interception of a late pass sealed a narrow 54–52 win that sent Butler back to the Sweet Sixteen. The Bulldogs' next opponent was the region's top seed, Syracuse.

Syracuse's famous zone defense took a bite out of Butler's typically strong shooting. The Bulldogs hit just 40 percent of their shots from the floor and went 6 for 24 from deep. The team from Indianapolis finished the first half up by 10 points, however, and hounded the Orange with tight man-to-man defense. Most importantly, the players didn't give up.

"These guys have resolve," Brad Stevens said after the game. "It's hard to measure, but they've got it." Resolve got the job done. Butler advanced to the Elite Eight for the first time ever, beating Syracuse 63–59.

Kansas State was next. Gordon Hayward scored twenty-two, but it was Butler's guards who shut down the Wildcats. Ronald Nored and Willie Veasley glued themselves to Big Twelve stars Jacob Pullen and Denis Clemente, and Shelvin Mack chipped in sixteen points to send Butler to the Final Four at Lucas Oil Stadium. Being "sent home" was a bad thing for

Indianapolis pro sports venues like Lucas Oil Stadium and Bankers Life Fieldhouse pay homage to the classic architecture of Hinkle Fieldhouse. *Author's photo.*

Butler's opponents. It meant they had been eliminated. For this particular squad, being sent home was a reward for winning again and again.

Brad Stevens kept his jubilant players' eyes on the ultimate prize. "Certainly this is going to be a highlight for all of us," he said. "But you're always moving to the next thing."

The next thing was a date with the Michigan State Spartans. Bobby Plump was in the house as Butler attempted to create a collegiate version of the Milan Miracle just a couple of miles from legendary Hinkle Fieldhouse, where Plump's shot had earned him everlasting fame.

Tom Izzo's Spartans were weakened by injuries, but they battled hard. Gordon Hayward played with a bloody lip. Matt Howard cracked heads with Draymond Green. Shelvin Mack sat on the bench for most of the second half with intense leg cramps. Butler didn't score for nearly eleven minutes at one point but held on to win by a score of 52–50.

Butler was on a 25-game win streak. By defeating Kansas State, the team had escaped March without a loss and now owned its first-ever April victory. There was only one game remaining. The national title game would match Duke's Mike Krzyzewski, soon to become the winningest coach in NCAA history, against Brad Stevens and his turbocharged 89-15 total, built over just three seasons as a head coach.

None of that really mattered. The players on the floor were well matched. Duke seized a small early lead, and then Butler went ahead by 2 on a Willie Veasley tip-in. At the end of the first half, the Bulldogs had proven once again that they belonged at the highest level of college basketball. The score was 33–32 in favor of the Blue Devils as the teams went into the Lucas Oil locker rooms for halftime.

The second half was hotly contested. A moment came when a Duke run put the ACC team up by five, but the Bulldogs chipped away, refusing to give up with the prize so near. A Matt Howard layup with fifty-four seconds left in regulation again brought Butler within one point of making history.

The final sequence is etched in the memory of all who watched, whether live in the reconfigured football stadium, on giant projection screens in Hinkle Fieldhouse or at home on the couch. Gordon Hayward missed a fourteen-foot baseline fader with Duke center Brian Zoubek's hand in his face. Zoubek was fouled after the miss and hit the first of two free throws. Zoubek's second shot was an intentional miss. Hayward snatched the rebound, turned and slung a prayer from beyond the halfcourt marker. Thousands held their breath as the ball made a beeline for Duke's goal, hit the backboard and barely front-rimmed out. Duke

won its fourth national title under Krzyzewski by the margin of a couple of inches.

Hayward finished with twelve points and eight rebounds, but the one that got away would haunt him and fans around the world.

Kyle Whelliston, the bard of mid-major hoops who had coined the term "it always ends in a loss" to describe the pain of rooting for a small school like Butler, sounded a note of hope in his final column of the season at his website, midmajority.com:

> *I imagine how the world would be if that half-court shot (or the one before it) had gone in. It would have been...perfect. It's not now. And I don't know if it will ever be that close again. It was almost* Hoosiers. *It almost didn't end in a loss. They almost won this one for all the small schools that never had a chance to get here. But they didn't. Please tell me they can try again next year?*

Whelliston's forlorn words of hope would prove to be prophetic.

MARCH MYSTIQUE RETURNS

Butler did not exactly look unbeatable as the team attempted to return to the NCAA tournament, one season after surprising the world with a successful Final Four appearance. The Bulldogs were a desultory 5-4 as they prepared for an unprecedented event: CBS would televise Stanford's visit to Hinkle Fieldhouse to a national audience. The network had never before included Butler in its weekend programming.

It had been forty-five years since a Pac-Ten team had paid a visit to Hinkle, and 8,012 fans filled seats at the field house, expecting to see a good game and hopefully a much-needed win before their beloved Bulldogs headed off to the Diamond Head Classic in Honolulu, Hawaii.

Six-foot-eight forward Matt Howard would be matched up against taller Stanford players in the post. As the game played out, Howard found that he had room to score farther away from the basket. He hit both of the 3-pointers he attempted and didn't miss a free throw when Stanford put him on the line. He scored 10 straight points at the beginning of the second half. When his personal run of points ended, he had outscored Stanford's entire team 23–22. He ended with 27, and Butler had a stunning 85–30 win.

Perhaps more tellingly, Butler held Stanford to 31 percent shooting in the game. Defensive efficiency was key to Butler's ability to beat more athletic teams from mega-conferences. Their confidence bolstered by the home win, the Bulldogs beat Utah, Florida State and Washington State in Hawaii, claiming the Diamond Head Classic title.

Butler entered Horizon League play on a high. The team generally played well at home that season, but a fateful early loss to Milwaukee in Hinkle and a 13-5 league record overall meant it entered the league's postseason tournament hoping to claim an automatic bid to the NCAA tournament. The selection committee was not typically kind to second-place finishers in so-called mid-major conferences. The tournament was played in Milwaukee that year.

The Bulldogs defeated Cleveland State and future NBA champion Norris Cole for the third time that season in the semifinal, setting up a rematch with Milwaukee in the Panthers' hometown. Butler breezed past its hosts 59–44 to book a return trip to the Big Dance. Matt Howard again came through, leading all scorers with 18 points. Shelvin Mack added 14.

This would be the beginning of another magical string of March wins for Butler. Sent to Washington, D.C., for its first NCAA tournament game, the Bulldogs narrowly defeated Old Dominion by two points. Two days later, only one point separated them from Pittsburgh when the final buzzer sounded. However it happened, Butler was back in the Sweet Sixteen.

In New Orleans, Butler would face a tough defensive team. Wisconsin under Bo Ryan had never missed an NCAA tournament and tended to grind down opponents. Howard and Mack again worked the perimeter to perfection, sending the Badgers home with a 61–54 loss. In the Elite Eight, Butler would meet frequent postseason foe Florida. Despite being down as much as 11 points in the second half, Butler stormed back to force overtime. Shelvin Mack's 3-pointer with 1:21 left in overtime gave the Bulldogs a lead they would not relinquish.

In the Final Four, held in Houston, Butler would meet a foe with an even stronger claim to the underdog title. Virginia Commonwealth had come from the so-called First Four (a series of play-in games allocated to the last teams to make the field) all the way to the Final Four. VCU's Havoc system was predicated on aggressive, full-court defense; hot shooting; and speed. Butler put an end to the Rams' Cinderella run with rebounding prowess and stifling defense. Shelvin Mack scored twenty-four to lead Butler back to the national title game.

Afterward, CBSSports.com writer Matt Norlander acknowledged the contributions of players like Howard and Mack but lauded the efficient

consistency of head coach Brad Stevens in mentally preparing his charges for the repeat Final Four appearance:

> *At the postgame podium, Stevens, sitting with perfect posture, looked like he was penning a letter to someone as Matt Howard and Mack took questions from the media. Stevens wouldn't be asked direct questions until the student-athletes left the podium, so he took in the precious time he had to chart his team's statistics or trends before dealing with a few questions. I have never seen another coach do this.*
>
> *Bottom line: none of this happens without Stevens. It is a mid-major marriage unlike anything college basketball's ever had. And with the Bulldogs' return to the title game, a return to form and character: underdog. Stevens will have this team prepared and ready, again. There's no one better for the task. He is the perfect coach for this program.*

Butler faced Connecticut in Reliant Stadium in the final game of the season. Butler was on a 14-game winning streak. UConn, led by relentless, creative scorer Kemba Walker, had finished 9-9 in Big East play that season. The Huskies had to win 5 straight games in the Big East tournament to

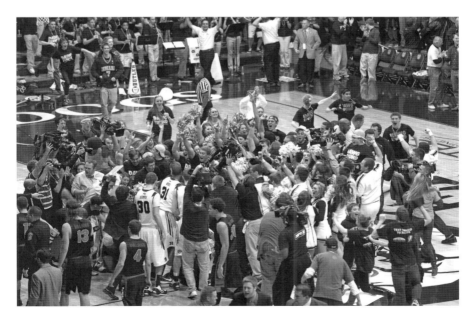

Butler players celebrate with fans after beating Gonzaga after a last-second winning shot. *Butler University.*

earn their way into the Big Dance. After beating Kentucky in the second semifinal, their winning streak was up to 10 straight.

As exciting as the matchup sounded, the national title game was tough to watch. UConn shot just over 35.0 percent from the floor, and that was the good news. Butler struggled to an abysmal 18.8 percent shooting mark. Both teams were sloppy, but Connecticut pulled out a 53–41 win for the program's third national title.

Butler had again showed that a small school could challenge for a national title. The moral victory was soured a bit the second time around. Brad Stevens seemed ready, willing and able to turn out a Butler team that would get over that final hump. The rightful fear that nagged at Butler fans was that Stevens's growing popularity would entice a big-time program with more resources to lure him away.

Stevens resisted that lure for two more years, guiding Butler to a disappointing third-place finish in the Horizon League in 2012, then back to the NCAA tournament in his final season. The team that convinced Stevens to leave Hinkle was no cash-rich college program but the Boston Celtics. Even Butler fans, who would miss Stevens terribly, had to admit that he had given the program his all and had accepted a job offer that would have tempted anyone.

REALIGNMENT

Following Butler's back-to-back title game appearances, the school seemed to outgrow the Horizon League. As much as the Bulldogs enjoyed their midwestern rivalries, the fact remained that the Horizon was, at best, a two-bid league. More often, only the conference's tourney winner would get a ticket to the Big Dance.

Realignment and conference shuffling have happened periodically throughout the history of college athletics. In the new millennium, however, the financial might of college football had ignited a frenzy of conference-hopping. Butler, though a very attractive basketball program, did not play in Division 1's Football Bowl Subdivision (FBS). If the Bulldogs were to find a more challenging conference home, they would have to find a hoops-centric league with some clout.

The Atlantic Ten seemed like a perfect fit. The league had placed multiple teams in the NCAA tournament on a regular basis, making it a more

ESPN's *College Gameday* came to Hinkle in January 2011. The crew reported live from the field house floor, surrounded by fans who were preparing for Butler's appearance later that evening. *Butler University.*

attractive home for strong mid-majors. Butler and fellow 2011 Final Four participant VCU joined the league in 2012.

Butler thrived in the new league—finishing 11-5 in conference play, 27-9 overall—and returned to the NCAA tournament. One of the most memorable games the team played that season was a marquee nonconference matchup with Gonzaga, the team that had practically coined the term Cinderella (in relation to basketball) by making it to the Elite Eight in 1999.

ESPN's *College Gameday* show, which was televised live from a different campus each week, elected to open its season slate with a visit to the field house for the game. It was an attractive location for many reasons. The narrative between the two teams, both nicknamed "Bulldogs," was strong. The early season matchup of two ranked teams—Gonzaga was then ranked number eight nationally, and Butler was number thirteen—was a big draw as well. Finally, the network realized that the Hinkle Fieldhouse mystique would look great on television.

A camera crew arrived in advance of the *Gameday* set. The crew spent ten hours in the building, shooting footage of the various historical trophies and mementos stashed away inside. *Gameday* host Jay Bilas, who played college hoops at venerable Cameron Indoor Stadium, recognized Hinkle's special appeal.

"I think Butler's one of those places where there's a long-standing tradition," Bilas told reporters. "People take pride in the program, and they take pride in the venue, and rightly so."

The game tipped off at 9:00 p.m. on January 19, 2013. The old court seemed to glow in the overhead lights and thrummed with the energy of the Butler fans in attendance. The game was a back-and-forth affair that came down to an agonizingly exciting final sequence, best described by the game story from the *Indianapolis Star*:

> *Walk-on Alex Barlow nearly reprised his hero's role from Butler's upset of No. 1 Indiana, banking in a go-ahead basket with 24 seconds left. But Kelly Olynyk sank two free throws with 4.6 on the clock, sending Gonzaga ahead 63–62. Barlow caught the inbounds pass but traveled, returning the ball to the Zags.*

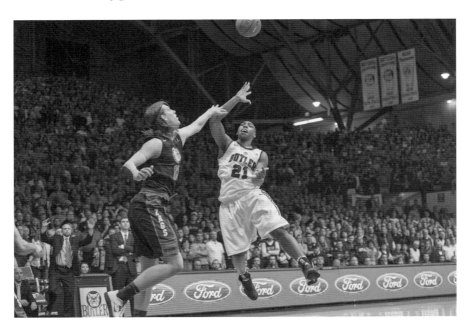

Roosevelt Jones's buzzer-beating shot over Gonzaga seven-footer Kelly Olynyk capped one of the field house's most memorable games in 2012. *Butler University.*

Roosevelt Jones stole [Gonzaga's] inbounds pass, dribbled upcourt and sank a 14-foot floater at the buzzer to lift No. 13 Butler over No. 8 Gonzaga 64–63 Saturday night before a sellout crowd of 10,228. "A little bit of Hinkle magic," Butler coach Brad Stevens said.

The miraculous steal, followed by a floating layup over the towering Olynyk (who would later play for Brad Stevens and the Boston Celtics), capped an amazing day for Hinkle Fieldhouse.

The field house hosted some thrilling overtime victories in later seasons, including an overtime win over Vanderbilt in November 2013 and another extra-period victory in January 2014, this time over new Big East foe Marquette.

The Hinkle mystique, honed over decades, was still powerfully in effect. The question remained, however: as the Bulldogs moved from the Horizon to the Atlantic Ten to the Big East, would the field house continue to stand the test of time?

The answer would be an emphatic "Yes!"

12

THE CAMPAIGN FOR HINKLE

On November 9, 2012, Butler University announced a public fundraising initiative. The school already had $12 million in gifts and pledges banked and hoped to add $16 million more. In the wake of back-to-back Final Four runs and looking forward to its intention to join a larger conference, the school made the decision to invest those funds in the renovation of historic Hinkle Fieldhouse. The cause was an easy sell. Donations topped $17 million when all was said and done.

Of course, it wouldn't do to change the essential character of the building in any way. Not only was the idea anathema to all who loved the building, but also its status as a national landmark would not allow dramatic changes.

"Lots of times, you'll have clients who want to do certain things without recognizing the importance and significance of the building," said architect and preservationist David Kroll, who worked on the Hinkle renovation for Ratio Architects. "But it was really different at Butler. Barry Collier from the get-go was saying we need to keep this cathedral of basketball the way it is, with the understanding that we need new locker rooms, better sight lines, better mechanical systems, floor boards—that kind of stuff—to enhance the customer experience and then the back of the house things to enhance the student athlete experience."

"Everyone who's ever been in the field house has a feel for it or knows it has a feel," said Collier. "It has some character-defining features that you should not touch. We talked about over our dead bodies would you want to change the feel. Those defining features are the high-arching I-beams

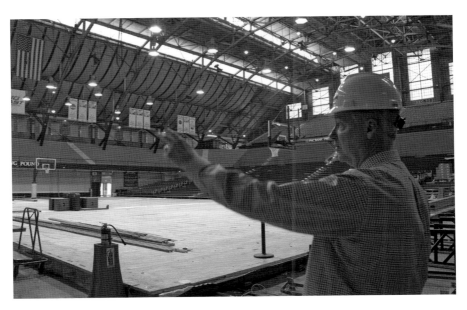

Barry Collier points out key aspects of Hinkle's 2014 renovation, which coincided with the team's move into the Big East conference. *Author's photo.*

through the ceiling, the sunlight through the windows, the shape of the bowl and the exterior, of course. The footprint of the building, you can't mess with. It's a preservation project."

Some consideration was given to the notion of building an extension to connect the field house to the neighboring recreation building, but that plan was ultimately scrapped. Instead, a plan to repurpose existing space was hatched. It involved digging out the seldom-used indoor pool in the western extension.

"As we understand it, the pool was the first indoor pool in the city of Indianapolis, but they put in cement block in the windows eventually, probably to stop moisture break in. So it was very dark and not used very much at all since the '90s," Collier said. "When we dug all that out, we're left with three stories times six thousand square feet, still inside the four walls of the building. So that became new space we can use."

Collier made these remarks from his temporary office, a contractor-style temporary mobile office set up outside the west façade of the field house. He would be there until the new athletic offices, built in part of that repurposed space, were completed. He pointed out that the new office space has visible benefits for fans visiting the building. The lower concourse had become

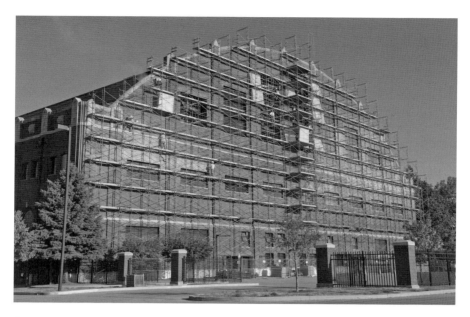

In 2014, the iconic eastern windows at Hinkle Fieldhouse were fitted with energy-efficient panes of glass as part of the Campaign for Hinkle renovation project. *Butler University.*

cramped over the years, as athletic offices were built along outer walls, sticking out into the corridors. "We took those out, so it will actually be closer to 1928. If you've been here before, you'll notice the offices are gone, but we're hoping it looks more like it's been that way all along."

Field house renovations often encompass improvements in accessibility. Many changes were made in 1989 to bring the building into compliance with the Americans with Disabilities Act. Hinkle's ramps to the upper concourse were revolutionary when construction began in 1926, and they will remain. But there will now be an elevator as well—Hinkle's first.

"We had to do some gymnastics to get the elevator to match up with the existing floor levels and then the new levels we were building in the natatorium," Kroll said. "It was kind of a three-dimensional jigsaw puzzle."

Fans will benefit from additional chair-back seating, which will replace some authentic but uncomfortable bench seats. A new video scoreboard has been installed, and restrooms—never the best part of any aging structure—have been upgraded.

"The restroom count and accessibility was not enough for a modern sports venue," said Rob Proctor, principal architect of the project. "We laid

out some new restrooms where we had taken out the offices on the east and west ends and some in the center."

Butler's student-athletes will enjoy some behind-the-scenes improvements that spectators rarely see. The video rooms, sports medicine area and academic center have been upgraded. The weight room, which was tiny and outmoded by modern standards, has been expanded.

Not that some of those things won't be missed—"I'll always remember the old weight room fondly because it was such a small thing down in the back of Hinkle," Brandon Crone reminisced. "That's really where we got initiated as freshmen. We had something we called the second-story ab drop, where we dropped the medicine ball from the top of the thing down to the bottom on your stomach."

Work on the exterior of the building was very visible throughout the 2014 offseason. Windows throughout the building, including the iconic gable windows, needed a lot of restoration.

Renovations to the field house in 2014 included a video scoreboard, a first for the old barn. *Butler University.*

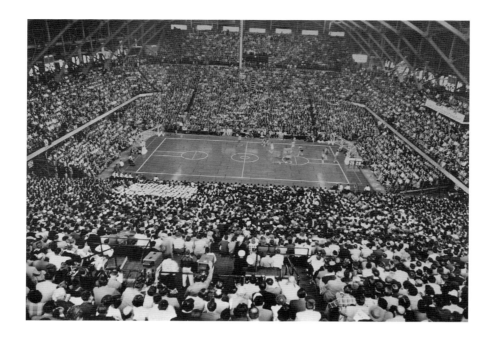

"At the start of the project, we had four, maybe five different types of glass in the windows," Kroll said. "We removed the steel sash and made repairs as needed and primed the metal with a corrosion-resistant industrial paint. We used clear glass in the office spaces and concourses and opaque glass on the high ends where you had sun glaring down onto the court. The opaque glass allows a diffused light to come through."

Cracks in some of the stone detail work required repair or replacement. The entire exterior was cleaned, as well.

The campaign to renovate Hinkle Fieldhouse ensured that the building would continue to serve the university and impress college basketball fans for decades to come. Rob Proctor feels that Hinkle speaks to the character of the city and state outside its walls. "It's quite modest," he said. "It really reflects the Hoosier conservativism. It sits there very humbly. There're no grand gateways."

Barry Collier agrees. "People appreciate Hinkle for what it is. Nothing's for everybody. But we've got a really good building, and we have nothing but appreciation for it."

Billy Shepherd, who practically grew up in Hinkle Fieldhouse, expects the building to live on and inspire more kids to dream big.

"I think it will be there a hundred years from now," Shepherd said. "I really do."

BIBLIOGRAPHY

"The American Presidency Project." http://www.presidency.ucsb.edu. Text of several presidential speeches.

Angevine, Eric. "Hoops History? Yes, the Butler Did It." ESPN. April 2, 2010. http://espn.go.com/espn/thelife/news/story?id=4748959. Accessed December 5, 2014.

Ashe, Arthur. *A Hard Road to Glory—Basketball: The African-American Athlete in Basketball.* New York: Amistad, 1993.

Bodenhamer, David J., Robert G. Barrows and David Vanderstel Gordon. *The Encyclopedia of Indianapolis.* Bloomington: Indiana University Press, 1994.

Boop, Roger. *Fulfilling the Charter: The Story of the College of Education at Butler University.* Bloomington, IN: iUniverse, 2008.

Caldwell, Howard, and Bobby Knight. *Tony Hinkle: Coach for All Seasons.* Bloomington: Indiana University Press, 1991.

Dauster, Rob. "Report: South Alabama to Hire Matthew Graves." March 25, 2013. Accessed December 6, 2014.

Davis, Seth. *Wooden: A Coach's Life.* New York: Henry Holt & Company, 2014.

Eisenberg, Jeff. "No. 9 in the Untouchables: Darnell Archey's Free Throw Streak." Yahoo.com, June 5, 2012. Accessed December 6, 2014.

ESPN College Basketball Encyclopedia: The Complete History of the Men's Game. New York: Ballantine Books, 2009.

Feinswog, Lee. "The Line That Changed the Game." NCAA.com, January 25, 2012. Accessed December 5, 2014.

Fulks, Matt. *Echoes of Kansas Basketball: The Greatest Stories Ever Told.* Chicago: Triumph Books, 2006.

The Games of August: The Tenth Pan American Games. Indianapolis: Showmasters, Inc., 1987

BIBLIOGRAPHY

Gerster, Darlene, and Roselyn McKittrick. *Milan, Indiana: A Storied Past.* Milan, IN: Milan '54, Inc., 2004.

Gipson, John, and Stan Patton. *Winners.* N.p.: self-published, 2003.

Guffey, Greg. *The Golden Age of Indiana High School Basketball.* Bloomington: Quarry Books/Indiana University Press, 2006.

Holbriech, Curt. "U.S. Outlasts Cuba for Gold Medal." LATimes.com, August 24, 1987. Accessed December 6, 2014.

Indianapolis Star. Various articles.

Johnson, Gayle. *The Making of* Hoosiers. N.p.: self-published, 2010.

Kerkhoff, Blair. *Phog Allen: The Father of Basketball Coaching.* Indianapolis: Masters Press, 1996.

Lighty, S. Chandler. *Montgomery County Historical Profiles: The First Indiana High School Basketball Tournament Champions 1911 Crawfordsville High School.* Crawfordsville, IN: Montgomery County Historical Society, Inc., 2009.

May, Bill. *Tourney Time: The Indiana High School Athletic Association Boys Basketball Tournament 1911–2003: Brief History, Complete Scores and a Referee's Memoirs.* Indianapolis: Guild Press Emmis Books, 2003.

Moore, Joseph Thomas, and Paul Dickson. *Larry Doby: The Struggle of the American League's First Black Player.* Mineola, NY: Dover Publications, 2011.

Naismith, James. *Basketball: Its Origin and Development.* Lincoln: University of Nebraska Press, 1996.

Norlander, Matt. "Butler's Back-to-Back Success a Direct Result of Stevens." CBSSports.com, April 2, 2011. Accessed December 5, 2014.

Robertson, Oscar. *The Big O: My Life, My Times, My Game.* Lincoln: University of Nebraska Press, 2010.

Roberts, Randy. *"But They Can't Beat Us!": Oscar Robertson and the Crispus Attucks Tigers.* Champaign, IL: Sports Pub, 1999.

Smith, Jean Edward. *Eisenhower in War and Peace.* New York: Random House, 2012.

Sutton, Susan. *Indianapolis: The Bass Photo Company Collection.* Indianapolis: Indiana Historical Society Press, 2008.

The Tenth Pan American Games Official Program. Lexington, KY: Host Communications, Inc., 1987.

Washburn, Jeff. *Tales from Indiana High School Basketball.* New York: Sports Pub, 2013.

Whelliston, Kyle. *One Beautiful Season.* N.p.: Flat Roof Press, 2010.

Williams, Bob. *Hoosier Hysteria! Indiana High School Basketball.* South Bend, IN: Hardwood Press, 1982.

Winn, Luke. "Hinkle Fieldhouse, Before the Madness." SI.com, March 31, 2010. Accessed December 5, 2014.

Woods, David. *The Butler Way: The Best of Butler Basketball.* Indianapolis: Blue River Press, 2009.

INDEX

A

ABA All-Star game 85
Alabama-Birmingham
 Blazers 136
Alabama Crimson Tide 32
Alcindor, Lew 82
Alford, Steve 102, 103,
 104, 105
Allen, Forrest C. "Phog"
 52, 53, 113
Amateur Athletic Union 25
American Basketball
 Association 85
Americans with Disabilities
 Act 148
Anderson High School 67
Anderson Packers 55
Anspaugh, David 62,
 105, 107
Archbold, Darrin 120
Archey, Darnell 122,
 123, 124
Argentina 110
Arizona Wildcats 122
Arkansas Razorbacks 32
Arsenal Technical High
 School 65

Arthur Jordan
 Conservatory of
 Music 39
Arthur Jordan Memorial
 Hall 12, 18
Assembly Hall 14, 100
Atlantic Ten Conference 145
Aurora High School 59

B

Bailey, Damon 112, 114, 120
Bainbridge High School 76
Bannister, Geoffrey
 116, 117
Barlow, Alex 7, 144
Barnstable, Dale 56
Basketball Association of
 America 55
Bayh, Birch 22
Baylor Bears 130
Beard, Ralph 56
Beas, Mike 121
Bedford North Lawrence
 High School 112
Bedford North Lawrence
 Stars 112
Bell, Harry 32

Ben Davis High School 121
Bennett, Dick 120
Big East Conference 6,
 141, 142, 145
Big Ten Conference 15,
 31, 54, 90, 91, 134
Bilas, Jay 144
Bird, Larry 95, 100
Birmingham, Alabama 126
Bishop Chatard High
 School 107
Bloomington, Indiana 63,
 105, 120
Blue, Jeff 76, 77, 78
Blue, Mike 76
Bluffton High School 14
Boop, Roger 46
Boston Celtics 142, 145
Bowling Green Falcons 78
Bowman, Tom 78
Bradley Braves 78
Brazil 110
Brigham Young
 Cougars 32
Brown, Larry 86
Bryant, Hallie 71
Bubas, Vic 82

Buchanan, Gary 123
Bugg, William 27
Burnley, Willie 69
Bush, George H.W. 108, 128
Bush, George W. 128
Butler Blue Sox 18
Butler Bowl 44
Butler, Demia 10
Butler Fieldhouse 10, 12, 18, 19, 27, 33, 36, 41, 51, 52, 55, 59, 63, 65, 71, 72, 74, 80, 84, 91, 106
Butler, Ovid 10, 11, 117
Butler Relays 36, 38
Butler University 10, 11, 12, 16, 17, 31, 32, 39, 43, 65, 78, 82, 84, 92, 98, 117, 118, 128, 146
Butler Way, the 8, 30, 47, 89, 92, 102, 117, 120, 121, 132, 134

C

Caldwell, Howard 16, 26, 31, 49, 77, 78, 89, 114
Cameron Indoor Stadium 144
Cannon, Fermor Spencer 18, 19, 28
Carlson, H.C. "Doc" 27
Carmel High School 93
Carnegie, Tom 92
Carr, Austin 91, 92, 93
Carson, Julia 128
Castro, Fidel 108
Cat and Mouse 59, 60, 61
Chase, Chevy 97
Chrabascz, Andrew 8
Cincinnati Bearcats 32, 49, 120
Cincinnati, Ohio 57

Clark, Potsy 32
Clemente, Denis 137
Cleveland State Vikings 124, 140
Clinton, Bill 6, 128, 129
Cobb, Ty 42
Cochran, Mickey 45
Coleman, Maxine 71
Cole, Norris 140
Collier, Barry 113, 114, 117, 118, 120, 121, 122, 134, 146, 147, 150
Columbus High School 67
Conley, Mike 128
Connecticut Huskies 141, 142
Connersville High School 66
Conseco Fieldhouse 100, 123, 130
Cornette, Joel 123
Cousy, Bob 50
Craft, Ray 121
Crawfordsville Athenians 12, 84
Crawfordsville High School 74, 75, 80
Creighton Bluejays 7
Crispus Attucks High School 63, 81
Crispus Attucks Tigers 59, 63, 66, 70, 71
Crone, Brandon 127, 130, 131, 132, 149
Crowe, Betty 65
Crowe, Ray 64, 65, 66, 68, 69, 70, 71, 81
Crown Hill Cemetery 117
Cuba 110
Curry, Stephen 103
Curtis, Glenn 21, 22

D

Daniels, Mel 86
Danville Normal College 27

Davidson Wildcats 103, 135
Davis, Mike 123
Davis, Seth 21
Dearborn Gymnasium 45
Deford, Frank 80
Deitz, Bob 48, 114
DePaul Blue Demons 6
DePauw University 27, 134
Despaigne, Joel 110, 111
Detroit Mercy Titans 103
Detroit Tigers 42
Diamond Head Classic 139, 140
Doby, Larry 45
Donovan, Billy 102, 120
Doyle, Jimmy 50
Duke Blue Devils 82, 124, 138, 139
Dungy, Tony 131
Dunham, Kellen 8

E

East West College All-Star Game 84
Eisenberg, Jeff 124
Eisenhower, Dwight D. 72, 73, 74, 129
Eison, Wilson 68, 69
Elite Eight 140
Ere, Ebi 126
Eskew, Phil 82
ESPN *College Gameday* 143
Eubank, George 24
Evans, Bob 55
Evansville, Indiana 97
Evansville Purple Aces 27, 100, 135
Evansville Reitz High School 65

F

Fab Five 113
Fairview Amusement Park 12

Federal International
 Banking
 Company 36
Final Four 102, 134, 136,
 138, 139, 140, 141,
 143, 146
Fitzgerald, Darrin 101,
 102, 103
Florida Gators 120,
 132, 140
Florida State Seminoles
 134, 140
Ford, Gerald R. 96, 97,
 98, 100
Fort Wayne, Indiana 63
Fort Wayne North High
 School 68
Fort Wayne South Side
 High School 75
Frankfort High School
 59, 127
Franklin High School 80
Freedom Hall 80, 87, 95
French Lick, Indiana 58, 95
Fromm, Erik 8

G

Garrett, Bill 51
Gary, Indiana 68
Gary Roosevelt High
 School 68, 69
Georgetown Hoyas 5, 6, 7,
 8, 135
George Washington
 University 43
Glascock, Dave 15
Gonzaga Bulldogs 124,
 130, 143, 145
Goudsouzian, Aram 65
Graves, A.J. 130
Graves, Matthew 124
Great Lakes Naval Base 45
Green, Draymond 138
Griggs, Haldane 26
Groza, Alex 56

H

Hackman, Gene 106
Hale, Bruce 82
Halleck, Charles 74
Hampton, Bill 66, 68, 69
Hansbrough, Tyler 127
Harding, Tom 43, 44
Haslam, Dick 75, 84
Haslem, Udonis 120
Havana, Cuba 109
Hawaii Warriors 124
Hayward, Gordon 136,
 137, 138
Hedden, Frank "Pop" 45,
 46, 47, 78
Helms Foundation 27
Hibbert, George 7
Hickory, Indiana
 (fictional) 57
Hildebrand, Oral 26, 27,
 30, 32
Hillyards College 25
Hinkle, Paul Daniel "Tony"
 8, 15, 16, 17, 18,
 25, 26, 27, 28, 30,
 31, 32, 33, 43, 44,
 45, 47, 49, 53, 58,
 74, 75, 76, 77, 78,
 80, 83, 84, 88, 89,
 90, 91, 92, 93, 95,
 100, 106, 114, 115,
 116, 117, 118, 121,
 126, 135
Hinkle System 59
Hitler, Adolf 39
Holbreich, Curt 110
Honolulu, Hawaii 139
Hoosier Classic 49, 54,
 76, 123
Hoosier Hysteria 12, 15,
 63, 80, 107
Hoosiers 6, 57, 62, 63,
 71, 101, 107, 117,
 130, 139

Hoover, Herbert 6, 33, 34,
 35, 36
Horizon League 122,
 125, 134, 135, 136,
 140, 142
Houston, Texas 140
Howard, Matt 136, 138,
 139, 140, 141
Huggins, Bob 120
Hughes, Emmet 74
Hungary 110
Hunt, Tiny 59
Huot, Claude 111

I

Idaho State Bengals 90
Illinois Illini 32, 76, 90
Indiana All-Stars 49, 51,
 87, 95
Indiana Basketball Hall of
 Fame 116
Indiana Central College
 27, 64
Indiana Collegiate
 Conference 76,
 88, 117
Indiana High School
 Athletic Association
 13, 31, 51, 57, 63,
 66, 80, 82, 87, 121
Indiana Historical
 Society 39
Indiana Hoosiers 48, 49,
 54, 120, 123, 124,
 130, 144
Indiana House of
 Representatives 71
Indiana Pacers 5, 57, 84, 128
Indianapolis Broad Ripple
 High School 104, 107
Indianapolis Exposition
 Center 22
Indianapolis George
 Washington High
 School 101

Indianapolis Hammond Tech High School 46
Indianapolis Jets 55
Indianapolis Lawrence North High School 112, 121, 127
Indianapolis Manual High School 80
Indianapolis Motor Speedway 108
Indianapolis North Central High School 7
Indianapolis Olympians 55, 85
Indianapolis Shortridge High School 12, 13, 93
Indianapolis Star 30, 32, 68, 100, 127, 128, 144
Indianapolis Times 82
Indianapolis Washington High School 49, 87
Indiana School Reorganization Act 75
Indiana State Sycamores 95, 100
Indiana State Teacher's College 20
Indiana State University 20, 95, 117
Indiana University 37, 52, 56, 76, 93, 100, 105
Indiana vs. Kentucky All-Star Game 80, 87
Iowa Hawkeyes 132
IUPUI 5
Izzo, Tom 138

J

jackass trophy 89
Jackson, Thomas 123
Jenner, William 72
Johnson, Emerson 51

Johnson, Gayle L. 105
Johnson, Lyndon B. 129
Jones, Collis 93
Jones, Roosevelt 145
Jordan, LaVall 121

K

Kansas City Athletic Club 26
Kansas Jayhawks 53
Kansas State Teacher□s College 25
Kansas State Wildcats 137, 138
Kearney, Jack 101
Kent State Golden Flashes 130
Kentucky Wildcats 142
Kerkhoff, Blair 50
Kilian, Gustav 43
Kiraly, Karch 108, 110, 111
Kissinger, Henry 97
Knight, Bob 102, 112, 114, 120, 134
Kokomo High School 80
Krause, Moose 92
Kroll, David 146, 148, 150
Krzyzewski, Mike 138, 139

L

Lambert, Ward "Piggy" 27
Lawrence North Wildcats 112
Lebanon High School 13, 14, 15, 80, 82, 84
Lebanon, Indiana 80
Lee, Gene 100
Lexington, Kentucky 78
Lickliter, Todd 122, 123, 124, 125, 126, 127, 131, 132, 134
Logansport, Indiana 15
Lombardi Trophy 131
Los Angeles Times 110

Louisiana State Tigers 135
Louisville Cardinals 32, 126
Louisville Courier-Journal 87
Lovellette, Clyde 50, 52
Loyola Ramblers 103, 124, 131
Lucas Oil Stadium 138
Lynch, George 113
Lyons, Fitzhugh 64

M

Maas, Charles 49
Mackey, Fred 33
Mack, Shelvin 136, 137, 138, 140, 141
Madison Square Garden 41, 130
Manual Training School 13
Marion High School 22
Market Square Arena 103, 108
Marquette Golden Eagles 6, 145
Marshall, George 72
Marshall, Khyle 7
Martinsville Artesians 11, 22, 24
Martinsville, Indiana 21, 22
Maryland Terrapins 132
Matta, Thad 122, 128, 133, 136
McCarthy, Babe 86
McCracken, Branch 48, 49, 52
McCreary, Jay 61
McGinnis, George 87
McGraw, John 15
McPherrin, Corey 98
Memorial Coliseum (Kentucky) 78
Merrill, Catharine 10
Merriweather, Willie 64, 66, 69, 71

Miami Dade Community
College 117
Michigan State Spartans
90, 138
Michigan Wolverines 78,
84, 113, 134
Midwestern Collegiate
Conference 103
Milan '54 Museum 61
Milan High School 49, 57,
59, 60, 61, 62, 63,
65, 70, 105
Milan, Indiana 57
Milan Miracle 57, 62, 63,
74, 105, 138
Miller, Brandon 7, 124, 125
Miller, Mike 120, 121
Minneapolis Lakers 53, 56
Minnesota Muskies 85
Mississippi State
Bulldogs 126
Missouri Tigers 26, 27
Missouri Valley
Conference 44
Mitchell, Sheddrick 66, 69
Montezuma High
School 59
Montross, Eric 112, 113, 114
Monument Circle 61, 70
Moorhead, Gus 58
Morrissey, Andrew 28
Morristown, Indiana 58
Mount, Rick 80, 82, 83, 84
Mr. Basketball 68, 87,
89, 128
Muncie Central Bearcats 61
Muncie Central High
School 22, 24, 61,
68, 75
Murdock, Jane 25
Murphy, Charles "Stretch"
22, 27
Murphy, Fred 106, 107
Murray State Racers 137

N

NABC Coach of the
Year 132
Naismith Basketball Hall of
Fame 53, 84
Naismith, James 11, 16
National Basketball
Association 5, 55,
56, 61, 80, 95, 140
National Basketball
League 55
National Collegiate Athletic
Association 27, 56,
74, 77, 102, 103,
122, 138
National Institute
of Animal
Agriculture 72
National Invitation
Tournament
120, 130
naval training school for
signalmen 46
NCAA tournament 7, 78,
88, 93, 112, 113,
120, 122, 126, 128,
134, 135, 136, 139,
140, 142, 143
Nebraska Cornhuskers 121
New Albany High
School 68
New Castle Fieldhouse 103
New Castle High School
103, 104
New Castle, Indiana 8,
104, 116
New Orleans
Buccaneers 86
New Orleans, Louisiana
140
Newton, C.M. 102
1980 Olympic Games 108
1988 summer
Olympics 108

1987 Pan Am Games
108, 110
Nipper, Bob 116
Norlander, Matt 140
Norris, Steve 90
North Carolina Tar
Heels 27, 105,
113, 127, 130
North Central Association
of Colleges 31
North Central
Conference 104
North Western Christian
University 10
Northwestern Park 70
Northwestern Wildcats 135
Notre Dame Alumni
Club 92
Notre Dame Fieldhouse 28
Notre Dame Fighting Irish
27, 28, 30, 32, 37,
54, 76, 78, 91, 92,
93, 130
Nova Southeastern
University 132
Nye, Peter 41, 42, 43

O

O'Brien, Ralph "Buckshot"
47, 49, 50, 56, 101
Oden, Greg 127
Ogden, R. Dale 36
Ohio Bobcats 93
Ohio State Buckeyes 38,
49, 90, 122, 128,
133, 134, 136
Oklahoma Sooners 126
Old Dominion Monarchs
132, 140
Olynyk, Kelly 144
Osgood High School 59
Overman, Kirby 95
Owens, Jesse 6, 36, 38

P

Page, Harlan "Pat" 16, 17
Pan American Sports
 Organization 108
Patton, Stan 68
Pearl, Bruce 125
Pennsy Gym 45
Peoria, Illinois 78
Phillips, Herman 36
Phoenix Suns 80
piano recital 39
Pike County, Indiana 50
Pitino, Rick 102
Pittsburgh Panthers 27,
 49, 140
Pizzo, Angelo 62, 63, 105,
 106, 107
Plump, Bobby 60, 61,
 70, 138
Plump, Tari 62
Polian, Bill 131
Pollard, Jim 85
Poplar Bluff High School
 (Missouri) 127
Porter, John 80
Power Memorial High
 School 82
Price, Hollis 126
Proctor, Rob 148, 150
Providence Friars 6, 102
Pullen, Jacob 137
Purdue Boilermakers 20,
 27, 31, 49, 54, 64,
 76, 84, 90

Q

Quito, Ecuador 108

R

Rabjohns, Jeff 127
Ratio Architects 146
RCA Dome 100
realignment 142

Reliant Stadium 141
Right Stuff, The 106
Robertson, Oscar 59, 60,
 63, 64, 65, 66, 68,
 69, 70, 81, 108, 116
Rochester Royals 56
Rockne, Knute 30
Roosevelt, Franklin Delano
 33, 34, 35, 36
Rubit, Augustine 124
Rudolph, Wilma 108
Rupp, Adolph 30, 78, 82
Rushville High School 59
Russell, Cazzie 84
Ryan, Bo 140

S

Santiago, Chile 108
Schooley-Woodstock 25
Schwomeyer, Herb 129
Scott, Bill 66
Secrist, Charlie 22, 24
Senior Night 124
Seton Hall Pirates 6
Sexson, Joe 102, 117
Sheets, Avery 125
Sheets, Pistol 81
Shelbyville High School 51
Shepherd, Bill 48, 93
Shepherd, Billy 74, 89, 90,
 91, 92, 93, 95, 101,
 150
Shepherd, Dave 93
Sicko, Don 103
Sigma Alpha Iota 39
Sigma Chi 100
Six-Day Bicycle Race 41, 42
Smith, Dean 113
Smith, Jack 61
Smith, Jean Edward 73
Smith-Rivera, D'Vauntes
 7, 8
Something to Cheer About
 64, 70

South Alabama Jaguars
 124, 134
South Bend Central High
 School 59
South Bend, Indiana 63, 78
Southern Illinois Salukis 131
Sports Illustrated 28, 80, 97
Springs Valley High
 School 95
Stagg, Amos Alonzo 15,
 16, 17
Stanford Cardinal 117,
 139, 140
Staples, Corrine Stanford 40
Stark, Pat 61
Starkville, Mississippi 126
Starlight Musicals 115
Stevens, Brad 134, 135,
 136, 137, 138, 141,
 142, 145
St. John's Redmen 6, 53
St. Joseph's College
 (Indiana) 91
Strack, Dave 84
Styx 100
Sutton, Susan 39
Sylvester, Bill 97, 114
Syracuse Orange 137

T

Tennessee Volunteers
 130, 134
Terre Haute Garfield High
 School 51
Terre Haute Gerstmeyer
 High School 60
Texas Tech Red Raiders 134
Theofanis, George 93, 117
Thompson, John 7
Thompson, John, III 7, 8
Thurmond, Nate 78
Timmons, Steve 110, 111
*Tony Hinkle: Coach for All
 Seasons* 27

Tosheff, Bill 56
Trester, Arthur 63
Trester Award 75
Tucker, Chad 102
Tulane Green Wave 49

U

University of California–
Los Angeles 19, 82,
104, 109, 135
University of Chicago 15,
16, 18, 27
University of Kentucky 55
University of Michigan
32, 38
University of Texas–El
Paso Miners 136
USA/Russia High School
All-Star game 100
Utah Running Utes 140

V

Valainis, Maris 107
Valparaiso Crusaders 89, 100
Van Arsdale, Dick 80
Van Arsdale, Tom 80
Vanderbilt Commodores
32, 102, 137, 145
Veasley, Willie 138
Versailles, Indiana 58, 59
Versailles Lions 59
Veterans Athletic
Association of
Philadephia 30
Villanova Wildcats 6, 123
Virginia Commonwealth
Rams 140, 143
Vopel, Heinz 43
Voskuhl, Joe 87

W

Wabash College 42, 100
WAJC 100

Wake Forest Demon
Deacons 122
Walker, Kemba 141
Washburn, Jeff 21
Washington, D.C. 43,
72, 140
Washington State
Cougars 140
Western Kentucky
Hilltoppers 80, 90
West Lafayette, Indiana 63
Whelliston, Kyle 139
White, Frank 30
Whiteland, Indiana 64
Wilkinson High School 67
Williams, Gary 132
Williams, Gerry 78
Winn, Luke 97
Winston-Salem, North
Carolina 120
Wisconsin Badgers 140
Wisconsin–Green Bay
Phoenix 136
Wisconsin-Milwaukee
Panthers 123, 124,
125, 140
Wooden, Cat 21
Wooden, John 19, 21, 22,
24, 27, 31, 82, 88
Wood, Marvin 49, 58,
60, 61
Woods, David 30, 47,
49, 94
Woods, Kameron 7
World Goalball
Championships 101
World War I 12
World War II 6, 43, 45, 72,
93, 101

X

Xavier Musketeers 7,
122, 136

Y

Youngstown State
Penguins 123

Z

Zoubek, Brian 138

ABOUT THE AUTHOR

Eric Angevine has written about basketball for ESPN, CBS and NBC, and he served as editor of the *Jayhawk Tip-Off* annual for three years. He fell in love with college basketball when he was growing up in Lawrence, Kansas. His love of American history has grown since he moved to Charlottesville, Virginia, with his wife and son.